PETER FLINSCH

ARSENAL PULP PRESS · *arsenalpulp.com*

PETER FLINSCH

The Body in Question

Ross Higgins

ARSENAL PULP PRESS
Suite 200, 341 Water Street
Vancouver, BC
Canada V6B 1B8
arsenalpulp.com

The publisher gratefully acknowledges the support of the Canada Council for the Arts and the
British Columbia Arts Council for its publishing program, and the Government of Canada
through the Book Publishing Industry Development Program and the Government of British
Columbia through the Book Publishing Tax Credit Program for its publishing activities.

Book design by Shyla Seller
All photographs courtesy of Peter Flinsch unless otherwise noted.

Printed and bound in Canada

Library and Archives Canada Cataloguing in Publication:

Higgins, Ross, 1948-
 Peter Flinsch : the body in question / Ross Higgins.

Includes bibliographical references and index.
ISBN 978-1-55152-237-1

 1. Flinsch, Peter, 1920-. 2. Artists—Canada—Biography.
3. Gay artists—Canada—Biography. I. Title.

N6549.F595H44 2008 709.2 C2008-902247-5

In memoriam Dorothy M. Higgins (1916-2007)

ACKNOWLEDGMENTS

Thank you Peter Flinsch, Thomas Waugh, Johanne Sloan, Philip Lewis, Erika Courvoisier, Joe Blonde, Mark Clintberg, Robert Vitulano, Kenny Bockus, Stuart Seeley, Matthew Ogonoski, Christian Bédard, Brian Lam, and Robert Ballantyne.

PREFACE

Thomas Waugh

> ... And the locker-room too is tiled and
> Clinical
>
> Where folding and hanging up the coarse collapsed
> Shapes of themselves,
> Trembling not shivering, much slighter in white
>
> Underwear the boys undress. Naked their bodies
> Sweat shadows of flesh as flesh, disguised in itself ...
> —*Patrick Anderson (1915-1979), "Y.M.C.A. Montreal" (1976)*

I first met Peter Flinsch in the locker room of the Montreal YMCA in
the late seventies. He was a handsome and well-tanned, barrel-chested
and well-hung, fiftysomething gentleman with an obvious eye for male
pulchritude. I could tell he was German from his accent, and assumed
he was checking out the local fauna just as I was—I didn't know this was
an artist's eye sizing up the raw material for his next ink and wash nude.
To this day, my favorites of Peter's works are his generic locker-room
scenes. He repeatedly comes back to this environment, fleshing out
with his customary mix of sensuality and irony the ambiguous sociality
of those primping and posing sweaty bodies, dressing and undressing
amid the benches and half-opened lockers, or haunting the steamy re-
cesses and shower carousels (Plates 38-41, 44, 47, 53, 55-57, perhaps 18
and 72, and of course 36, a glimpse of that other of my favorite steamy
spaces in Montreal, the Colonial "schvitz" bathhouse). Those were the
last of the legendary days—immortalized by the National Film Board (*I
Was a Ninety-Pound Weakling*, 1960) as well as by the under-recognized Ca-
nadian poet Patrick Anderson in my epigraph above, before the newly
co-ed Y went eroto-phobic, prudish, and cubicle-crazy. This book is a
timely opportunity for me not only to wax nostalgic about the spaces and
bodies that Peter has preserved, but also to relive my encounter with
this complex man with the sharp, roving, and concupiscent eye, and to

rediscover the brilliance of his art—especially those many corners of it that I did not already know—and for a new audience to discover for the first time the treasures of his life and art.

I don't remember when I got to know Peter outside of the YMCA context, but sometime later in the eighties his small works on paper started to appear framed on my walls and the invitations to his fabled eyrie on St Marc Street started to draw me into his world. Seen altogether, these images are not only exemplary accomplishments of figurative art, nor are they only beefcake, or mere portraiture or affectionate satire (especially the scenes of bars and clubs), but they are also ethnographic documentation of this world of his, worlds that have vanished and worlds that have lingered. Ross Higgins' delicious and masterly book, scholarly and insightful, does full justice to the marvelous worlds that Peter has both borne witness to and created through the process of art. It is no accident that Higgins is an accomplished historian and anthropologist, as well as Quebec's pioneering queer archivist, for all three of these vocations bring out the important aspects of Peter's oeuvre. We do not need to know about the artist's life to appreciate the beauty of his images, of course, but Ross's superb interviewing skills—not to mention tenacious community-building talents—have succeeded in bringing out the quirky contours and obsessive drive of Peter's life story. He has reminded us of the brave and innovative role Peter played in both the Canadian and international historical context, and has thereby succeeded in plumbing the depths of his art that we might not have otherwise imagined.

This book then is a felicitous meeting of two sets of bodies and minds, ears and voices, eyes and hands. The anthropologist/archivist/ historian makes an excellent art historian and critic. And, as we already know from the richness of these pictures, the artist makes an excellent anthropologist/archivist/historian. And of course, an unrivalled visual poet of "shadows of flesh." Enjoy.

Thomas Waugh is the author of numerous books, including Out/Lines, Lust Un-earthed, Hard to Imagine, *and* Gay Art: A Historic Collection *(with Felix Lance Falkon). He lives in Montreal.*

PETER FLINSCH: THE BODY IN QUESTION

Ross Higgins

Eighteen (and Gay) in Germany in 1938

As Oscar Wilde's wicked Lady Bracknell might have said, to be eighteen in Germany in 1938 was a misfortune, but to be eighteen and gay was a clear sign of recklessness. Vicious to the core, what then might Lady B. have said about the young Peter Flinsch getting caught kissing a subordinate at a Luftwaffe Christmas party at the end of 1942? But as things turned out, being sent to military prison and then assigned to a punitive work detail meant that Peter would survive the war and not die in the Battle of Stalingrad like most of his former comrades. Despite having had to get up each morning and publicly acknowledge his homosexual crime out loud to his fellow prisoners in this dark period, Peter was eventually released and returned to fight on the front lines; wounded in the final stages of the war, he managed to return to his parents' home in a town in eastern Germany. However, after a brief stint contributing to the official public art of the new Communist regime, he found himself swept up in the fluid theatrical and artistic circles of postwar Berlin. Here there was easy access to the West and, although he had no more than a high school education, Peter was able to find work as a designer and thus begin his lifelong career. His professional work in set design eventually brought him to Montreal in 1954 in the company of his long-time partner, ballet dancer Heino Heiden. While Heino returned to Germany at the end of the 1950s, Peter had a long and well-respected career as a television set designer at the Canadian Broadcasting Corporation/Radio-Canada. Behind the scenes, he slowly began to develop his artistic vision of the male form. This book represents a comprehensive look at his prodigious output in this undertaking, reflecting on events as much as possible in the artist's own words. The first extended conversation I had with Peter was a 1993 interview for my research on the development of the gay community in Montreal. More recently, I had the privilege of spending long hours with him, going over his work and talking about his life and experiences as a gay artist. The material here is based on those interviews and from the scrapbooks and files he has accumulated over sixty years as a working artist.

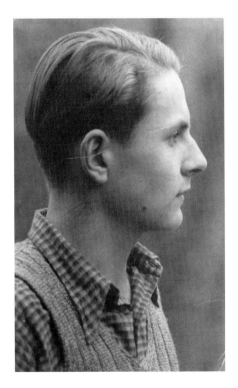

Peter Flinsch at sixteen.

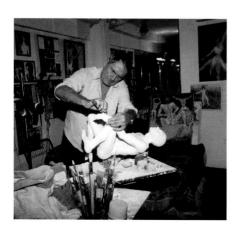

Flinsch at work on a sculpture, 1986.
Photographed by Alan B. Stone, courtesy of the
Archives gaies du Québec.

The Art of Survival

As the artwork in this book shows, Peter Flinsch's artistic gaze fastened on a wide range of men and their masculine occupations and preoccupations. Some show men as erotic, others as foolish. They are muscular, slim, or chunky; they are sober or drunk, serious or silly. In a few elegant pen strokes on paper, an immense canvas painted with oils or acrylics, or a sculpture in bronze, Peter Flinsch pursued his lifelong commitment to representing men, male sexuality, and male sociability. Men in movement and repose, real men, men seen on the bus, and then drawn after rushing home, or men seen only in the land of dream or phantasm, all capture the attention of the artist. "I am a camera," he repeats. He draws the world around him. He gets inside the gay gaze, expresses it, develops it, and presents it to the public for approval (or at times, to confront them with it). What I especially like, having tried in my own studies to capture moments of gay past experience, to render vivid in today's language where we have come from, is the clarity and focus of his drawings. They take the viewer into the heart of the moment. Some were made in the dark old clandestine days of shame and hiding, but Peter shows in the content of his pictures that those were also days of self-discovery—intellectual, emotional, individual, and collective. The gay communities of today emerged from a long process of development. The transformation of homosexuals from taboo outsiders excluded from the culture and harassed or victimized by society to today's vibrant, visible, full-fledged members of society took time, determination, and courage. Making pictures like these was a rare undertaking in the early 1960s and even the 1970s, yet Flinsch pursued his art with unwavering tenacity.

Shortly after 1960, Peter got to know fellow Montrealer Alan B. Stone, Canada's leading physique photographer and a notable artist whose work has only lately become known. "Being a painter," Peter says, "a visual man in the first place, I always bought the physique magazines." These magazines were one of the rare places where images of male bodies could be widely circulated at the time. Peter saw in Stone something of himself, another artist interested in imaging men, their bodies, and the way they meshed in the worlds of work, play, and home. As Peter explains in an interview in the video documentary *Eye on the Guy: Alan B. Stone and the Age of Beefcake* (Lewis and Monette, 2006), the two of

them got in Peter's car and went on photo shoots together to romantic locations outside the city with burly models crammed into the back seat. At least once, Stone got Peter to produce line drawings for one of his magazines (see Plate 63, *Matelot*, for an example). As the staid 1950s turned into the swinging 60s, Stone's magazines and the mail-order photo sales they generated were catching a wave of change. Men were coming to terms with their secret sexual identities and buying photos of men in posing straps by the handful. Stone would profit from his business for a few good years, and then finally retire as soft-core, then hard-core porn took over the male image market (see Thomas Waugh's *Hard to Imagine* for the full story). Meanwhile, with his full-time job as TV set designer ongoing, Peter continued to enjoy his slower-paced work with models in his studio, experimenting within a wide range of media and techniques as he perfected several modes for representing maleness. He has yet to retire.

An interesting contrast between these two Montreal artists is their relationship to their own sexuality. Stone was never "out" (except in his work, one might say), and having interviewed him jointly with author Waugh in 1991, I am not sure that he ever would willingly have referred to himself as gay or homosexual. But Peter's wartime arrest made his sexual identity paradoxically less problematic for him than for men like Stone, who never had to confront it so brutally. When you know that your opponents have already done their utmost against you short of murder, then you can just get on with your art rather than worrying about the morality of your identity. In fact, Peter made a point of buying prints of Stone's work from his friend André, Stone's model, because he was afraid the photographer would destroy his negatives during a police crackdown in the early 1960s.[1] Peter explains, "I know that he removed them from his house. I don't know if he actually destroyed them." In the end, most of Stone's work was saved.[2]

1 The story of the Caruso raid of 1961 was told by Stone in *Eye on the Guy*. But it is likely there was another series of raids in 1964 or so, for which no documentary evidence has surfaced.

2 Archives gaies du Québec collection. This collection provides evidence of the links between the two artists, though the shots Flinsch says were taken of him painting a model in the early 1960s have not surfaced.

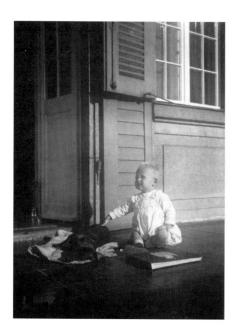

Peter Flinsch at one year of age.

Art at Home

Peter Flinsch was no stranger to the world of art, the history of the camaraderie and politics of artists, the multitude of techniques available to them for rendering the visual. Born into a well-to-do Leipzig family, his great grandfather Alfred Thieme was an industrialist who collected art, including two Rembrandts and a painting by Frans Hals. Peter compares his family to the upper-bourgeois German family in Thomas Mann's famous novel *Buddenbrooks*, who accumulate a lot of money but, by the third or fourth generation, become artists and free spenders. "Already my grandfathers did not work any more," he says. They lived off the family fortune and devoted their time to what they really liked. "My mother's father, Ulrich Thieme, my grandfather, became a very famous art historian and founded the leading artist's dictionary in Germany,[3] which still continues to this day because he created a foundation that would ensure it continued after his death." In addition to his scholarly interest, Thieme was also an art collector, as his own father, Peter's great grandfather, had been. As Peter says, "I grew up in those houses, which explains why it was a natural thing for me to choose the career of an artist."

Peter's mother had received an extremely liberal education while growing up. Nevertheless, when she announced she wanted to become a professional dancer, her father intervened. She eventually married Peter's father, who owned a paper factory on the outskirts of the city, but, scandalously, the marriage was quite short-lived. As Peter later learned, "It was a stormy divorce because my father was what we call today a playboy. He sort of squandered his money during the riotous years of the Weimar Republic in the 1920s." Peter grew up without knowing his father (he only met him during the war, by accident, one day when he was in Berlin with his mother). As a child in the house of his grandfather, where his mother returned after the divorce, he was brought up mainly by women, including a governess. "I didn't really miss my father at all," Peter says. (His mother did not remarry until Peter was sixteen.)

In this atmosphere, his artistic talent quickly blossomed. "My mother told me that I was drawing all the time once I found out that you could make lines and things with a pencil." Apparently some of his life-

3 *Thieme–Becker Künstler Lexikon.*

long favourite images come from these early experiences. He sometimes got into trouble for making art where he shouldn't. Once, "My grandfather was in bed because he was ailing and they put me on his bed and I came with a [pencil] and I started to paint a moon on his white bed sheet." Although his grandfather was one of Germany's leading art historians, "I don't think he was very pleased about artistic expression from his first grandchild!"

Few artists actually grow up in houses where Old Masters hang, where art is a serious daily subject of concern and conversation, or where art instruction is one of the matters parents consider in choosing schools for their children. In his teens, Peter was sent to private schools, where small groups of boys were taught by working artists the ways of the palette and the brush. The schools belonged to a prestigious chain of liberal boarding schools called the Hermann Lietz Schulen. He explained that the schools divided boys according to age group, thus avoiding the mistreatment of the young by much older students as was common in the English public school system. In each, the boys were organized into "families" headed by married teachers. The schools were in the countryside in old castles. Peter's first school was in Schloss Ettersburg, a castle of the Grand Duke near Weimar, where his roommate was the Prince of Hannover. Their education included manual labour. "We worked with animals and did farm work and all that. We also did carpentry. It was a very all-around thing."

Students received little in the way of sex education, beyond a lecture from the man who headed their school "family" about the evils of masturbation, which would make them weak. Peter recalls, "He said 'Save your strength for a good German girl' which was widely quoted throughout the school. It was right in keeping with the Nazi line of thought. So whenever we masturbated, we thought, what the hell, we're not going to save it for a good German girl." The school, not surprisingly, was a hotbed of passionate friendships, which included activities like mutual masturbation. Peter is still a close friend of one of his partners from school, though he says: "We are old gentlemen now. His life is heterosexual, but that did not, at that age, exclude a passionate boy's friendship. I see him every time I go back to Germany. He is happily married, grandchildren and everything. But we're still very, very close. He's really my oldest friend."

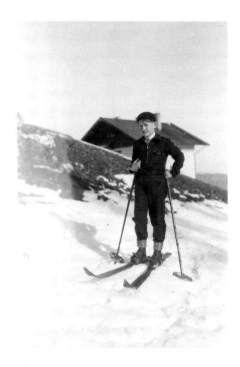

Flinsch on skis, 1930s.

There seemed to be little effort on the part of the school authorities to prevent such associations. But there were a few echoes of repression. On one occasion, a teacher suddenly disappeared; Peter later found out that he was asked to leave because it had been discovered that he had had passionate friendships with a few of the boys, but there was never much discussion of this occurrence.

Early on, Peter's artwork attracted the attention of his classmates; elegant gentlemen and ladies were his stock in trade, though the other schoolboys perhaps didn't notice the particular care given to the depiction of the gentlemen. His teacher saw his work in a different light, since his growing confidence as an artist meant that sometimes he refused to follow the rules. "I did it my own way. He wanted me to do architecture and perspective drawings—the way the shadow falls. He thought everything should be according to the rules. But I did it my way."

The milieu in which he was raised, exemplifying the artistic conventions of German society at the time, provided a certain stimulus to Peter's interest in representations of the male. One Leipzig painter, Sascha Schneider, was "definitely gay," according to Peter.[4] "He did a lot of official paintings, classical scenes, which allowed him to do naked [images]. He was very good but very stylized." One of his works decorated the high assembly room of the university. "One looks at it today and wonders how did he get away with it? But nakedness in this symbolic context was completely acceptable during his time." With this background, Peter was well-equipped to undertake a serious life-long artistic project, but history intervened.

The rise to power of the Nazis did not immediately affect the family, who were bourgeois liberals. Peter's new stepfather, who married his mother in 1936, came from a family he described as "ultra right-wing," and hated the Nazis for that very reason. But his parents were careful not to discuss politics in front of Peter. "It was dangerous," he explains, "because kids were encouraged to tell what was spoken about at home."

4 A web biography by John Coulthart mentions that Schneider contributed to *Der Eigene*, a popular German gay magazine of the pre-Nazi period. The artist is best remembered for his strangely symbolic illustrations for the books of Karl May. (*johncoulthart.com/feuilleton*; search for "Sascha Schneider").

At school, Peter, like all German children, was obliged to become a member of the Hitler Youth. The liberal schools resisted, but were under great pressure to conform. Students were forced to join if they wanted a higher education. The only special consideration the school managed was that they could form a separate group that did not include the boys from the village nearby. But Peter points out, "We were called Hitler Youth but it was basically the Wandervogel [the German youth movement oriented to fresh air and honest effort, etc.]. It was that same 'German Spirit.' They just changed the shirts." Certainly the aim of the new movement was to capitalize on the previous movements, but with more sinister ends than a mere change of shirts.

When it was time to graduate, Peter had to make his most important decision of his young life to date—whether to pursue art, or take a different, more conventional path. After a great deal of reflection, he chose to study architecture to appease his family. They had reacted typically to his assertion that he wanted to be a painter, imagining themselves supporting him for the rest of their lives. But an even more important dilemma still loomed: two years of obligatory military duty.

With no inkling of how the approaching war would change his life, Peter considered his options. He decided to complete his military service first so that his university education would not be interrupted later. Of course, this turned out to mean that he would never go to university at all, since when he emerged from uniform at age twenty-five in a world destroyed, it would be too late for higher education. Volunteering also meant that he could choose which service he would join. His mother had encouraged him to join the air force (Luftwaffe) so that he could serve in an anti-aircraft artillery unit, which she considered to be the safest place for him. Through her connections, she managed to make sure he would be accepted. But the war would nevertheless have fateful consequences for Peter's emerging sense of sexual identity as well as his educational destiny.

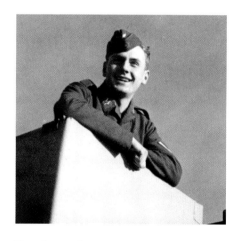

Flinsch in uniform, ca. 1940.

Peter's War

Once World War II started, Peter began training to become an officer, but, as he says, "I tried everything to stay away from it. I actually played dumb." However, as the war progressed, he was forced into it. His unit was at first stationed near Leipzig, his hometown. He said that he found

little time for sketching during the first year. "The first year of military service is very, very hard," Peter says, "because they break you in until you are broken. And then the war started. But during the war I kept a sketchbook ... I remember I did sketches wherever we were. In Russia, in Italy, in France, wherever. Eventually I sent it home to my mother for safekeeping." Anxious to preserve Peter's childhood drawings and sketches during the war, his mother placed them with other family valuables in a supposedly safe hiding place at a farm in the country, but in 1945, the farm was torched by advancing Soviet troops, although their home in the city home stood intact. Peter's sketchbook and almost all his early work was destroyed as a result.

Early in the war, Peter's unit was assigned to protect transportation, and travelled with cannons mounted on railway cars to wherever the war was: France, Belgium, Russia, and later Italy. Then they were assigned to protect airports, which took Peter to Sicily and North Africa. In 1941-42, they were assigned to a location protecting the centre of the city of Berlin, where no unit was allowed to stay more than a year since it was such a plum job. In Berlin, Peter, now well on his way to becoming lieutenant, had many social contacts in the best circles and got invited to many parties. As in cities fighting on the other side, wartime added an edge to Berlin social life. Despite the danger, people were eager to prove they could survive. As a member of an anti-aircraft unit, Peter was a popular guest because he could telephone his base for news of a coming raid and warn his hosts long before the air raid sirens sounded. "The spirit was not broken in Berlin—on the contrary," Peter says.

With his new status, Peter was able to go on leave in civilian clothes. His options for exploring his sexuality were limited, however. Although he heard that there was a homosexual bar somewhere in the city, going there was out of the question. But he was aware of his feelings. "Of course I knew," he said. "I found out pretty much after I turned eighteen that my preference was for men. I met some friends in the air force, but it was always very, very discreet. At the time, we were perfectly aware that the punishment was extremely severe. I had just become an officer and I had a passionate friendship with a young man in my unit, but he was my subordinate. We were found out by a sergeant who also served under me, but who obviously didn't like me very much."

Peter's arrest at the end of 1942 brought an abrupt halt to his

military career. He was lucky to escape with his life. "I was framed and the young man was forced to state that he had been propositioned by me. But nothing actually really happened." Peter was charged under the new Paragraph 175A of the German penal code. Since 1871, Paragraph 175 had made homosexual acts (sodomy) criminal, but after the Nazis came to power in 1933, they added the new provision, which criminalized even the attempt to commit an offence.[5] Thus no actual crime need have been committed if intent could be shown. As Peter explains, "They could not prove that anything really happened. I mean, the boy couldn't admit it because nothing had happened yet. This sergeant had watched us after a Christmas party when everybody was drunk, and he saw us embrace and kiss. He used this to blackmail the young man and then they went at me. During the night, they came and arrested me." The officer in charge told Peter that he must confess as it would make things easier. Peter was twenty-two, not old enough to recognize the trap. "So I confessed that I loved men," he says. "You know, that is the worst thing I could do under the Nazis, but I broke down and they got me. They accused me of a homosexual act. But it was no homosexual act, it was just a kiss."

The Luftwaffe authorities were in a great hurry, because the arrest had taken place December 24; on January 1, Peter was supposed to become a lieutenant, and thus would have the right to be judged by his peers. He was sentenced to three months in prison and then to a punitive unit (Strafkompanie, a unit for criminals) assigned to clearing minefields. The sentence was somewhat lenient, given the way the Nazis had been sending civilian homosexuals to prison and concentration camps under Paragraphs 175 and 175A since 1933. "It was a military tribunal ... They could not send me to a camp or anything. Had I been a civilian, of course, it would have been more severe, but I was a man in uniform. I had a rank, and it was a fighting unit."

Peter describes the rigours of life in prison in detail. "Of course it was difficult in prison. You had to line up twice a day and everyone had to say why he was there and what he had done. The 175ers were very much despised by everybody." He also got sick, and it was then that his case and sentencing were reappraised. "I was sent to the Torgau fortress where we had strenuous exercise and practically nothing to eat, and I

5 The new provision took effect on June 28, 1935. See Steakley (1975), 110.

became sick. Most of us became sick. After those three months, I wasn't even in a state to serve in a criminal unit."

Peter's well-connected family helped to reduce the consequences that he faced. His mother had a close friend, a woman she had been at school with, whose husband was General Friedrich Olbricht, the commander of Berlin. When Peter was court-martialed, she talked to her friend, and as a result the judgment was revised in order to show that he was not really homosexual. "I was evaluated by a leading psychiatrist in Berlin while I was in prison. I was sent there to make the fact that I had admitted loving a man seem like a youthful error or something like that. It all came about because of my mother." As a result, he was sent from prison to serve as a regular soldier on the front. There, he said, it was not supposed to be known what he had done. In one instance, however, the sergeant-major found out and he became very friendly with Peter as a result. "But I made it a point not to, you know … I was a heavily burdened child."

(Two years later, Peter's parents had reason to fear their connections to General Olbricht; he was one of the leaders killed after the July 20 Plot, the failed assassination of Hitler led by Count von Stauffenberg in 1944.[6] Another conspirator was the former mayor of Leipzig, Carl Goerdeler. "My mother and especially my stepfather they were much afraid because the Nazis went after all their friends." Ultimately, however, Peter's parents were not harmed.)

Getting arrested for a homosexual offence is a sure way to come out to your family, but Peter had no cause for fear. "My mother was allowed to visit me in prison before I was sent away. This, of course, was a great worry for her. She would tell me 'You're my son. I love you whatever happens.' And this probably saved my life, because at that point I was so down I didn't want to live anymore and probably would have taken a step to end it all, you know. It had been a downfall for me."

After being sent to clear land mines in North Africa and Russia, Peter was transferred to a fighting unit that used cannons with special ammunition against tanks on the ground. But, as Peter explains, he was "lucky" and contracted malaria. "Not the deadly type, but the milder which brings you down regularly for several weeks every three months. When I was diagnosed, I was no longer any good for front-line service.

6 Shirer (1959), 1385-88.

Each time I recovered, they tried to send me back to the unit, but my health didn't last very long. At the time, we did not have penicillin. We had something which only fought the symptoms, not the malaria itself." Earlier, he had been stationed at airports near swamps in North Africa and Sardinia and could have been bitten by a mosquito in either place. In any event, the malaria ultimately meant that to his superiors, he "was of no use anymore. Not even to die for them. But it's strange, isn't it, because the malaria could have killed me too. I guess I'm a lucky person."

War's End

Throughout the war, Peter's malaria had caused him to be in and out of hospital, assigned to a supply unit, and then sent back to the front again. But in the closing months of the conflict, he says, "I was wounded in Hungary in 1945, on my arm and down my side. I left on the last transport." However, his train was bombarded by an air attack in Czechoslovakia. "I could walk, mind you," he recalls, "but I had bandages and everything. We arrived in Prague at the central station, and we knew, of course, the war was lost." With this awareness, he and the other soldiers asked for what they wanted most: to go home. "We told the authorities that we were soldiers who were wounded, but that we didn't have our papers anymore. I said I was supposed to go to the military hospital in Chemnitz [where his parents had moved] ... Luckily, they gave me papers and sent me on to the town." Best of all, when he arrived, he discovered his parents were still living in their home, left standing in an area of the city almost completely destroyed.

But soon Peter, along with all the residents of Chemnitz, was to benefit from another stroke of luck. Though both American and Soviet forces were nearby, neither entered the city until May 8, the day when Germany officially surrendered. Thus, Peter, who attributes this fact to problems with the maps used at the Yalta conference, says that the city was spared the full fury of the initial Soviet conquest experienced by other German cities. By the time Chemnitz was taken by the Russians, Peter had left the hospital and returned to his parents' house.

The Russians quickly set about reorganizing the municipality and re-educating the population. They had the assistance of numerous German Communists, many from Chemnitz and other industrial

centres where there had been a strong labour movement; they had lived in exile in Russia during the war, where they were trained to take over the civilian government in Germany under Soviet command after it was over. According to Peter, "Some of them had been functionaries in the city before, and were placed in administrative roles. The administrator of culture was a woman. The chief of police was a former worker. The mayor was an intellectual. They and others established a city government, and announced that three political parties would be allowed." Initially they offered the appeal of an open political system. "Notices were put out to citizens asking them to clean the city, to rebuild free democratic German culture. Anyone able to contribute was asked to do so." Of course, these political freedoms were later eliminated.

Inspired by the appeal to freedom, Peter decided that as an artist he should get involved, so he went downtown and volunteered. He was interviewed by a woman, Comrade Rolla, who looked like the Hollywood stereotype casting for a female communist agent. "Uniform, jacket, tie, hair tied in a bun, glasses—of course, she was a lesbian! We got along splendidly. She said, 'Oh yes, you are a painter, you will have lots of work here.'" She told him about a group of painters already at work, including a stage designer and an architect. Soon he was assigned to work with an artist who had been trained as a *plakatmaler* (poster painter), creating huge canvas posters of film stars that were displayed outside movie theatres. Together they painted larger-than-life portraits of Lenin, Marx, Stalin, and Ernst Thälmann, the German Communist Party leader (imprisoned for eleven years by the Nazis and executed in 1944). These were hung outside city hall and other public buildings. He was not paid for this work, but received food and cigarettes. "I was now an artist of the people, and as such, privileged." With his newfound connections, Peter was able to secure the release of his stepfather, who as a member of the elite had been suspected of being a Nazi. Peter was able to vouch for him because, having been persecuted by the Nazis, he was not under suspicion himself.

Despite this scrutiny, Peter's stepfather decided that the family would remain in the East. Since his stepfather was only a manager and not an owner of the factory making textile machinery and had extensive international connections, the Communists persuaded him to stay. "The government realized the specialists were leaving. They made him

a fantastic offer to make him stay. They put him in charge of all textile machine production in the entire country." With their house and furniture intact, Peter's parents lived comfortably and eventually were able to move to Leipzig upon retirement. His stepfather's determination to stay came from his sense of duty and his conservative values; Peter remembers him saying, "I must rebuild the factories. My workers expect it." He chose not to see the politics. "He thought that the government was always right and they knew what they do. He was a typical old Prussian." For his loyalty, Peter's stepfather was granted an unusual amount of freedom; he and Peter's mother were allowed to travel to the West, although never together. His mother, who had wanted to leave East Germany, came to see him several times in Montreal. After she died, his stepfather confided to Peter that he should have listened to her, that staying was the worst mistake of his life.

In the early days of postwar Germany, cultural life was one the first things re-established by the occupying forces. "Re-education was the theatre, you know. So all those plays which had been forbidden during the Nazi years were performed again. Theatre was supported by the local government or by the Russians or Americans." Peter's future professional career started during this period of upheaval. "I volunteered to help at the theatre. I started being a painter for the stage and I learned the craft." This is how I became a stage designer and art director. I loved it. I discovered that this was what I wanted to do. He had been cheated out of studying architecture because of the war, but now he'd landed solidly on his feet doing something he liked.

Peter's connection to the stage brought about yet another stroke of luck which enabled him to escape from Communist East Germany. Through the theatre in Chemnitz, in 1945 Peter met Gabriele Hessmann, an actress who would also be his ticket to Berlin. "I met Gabriele and we got married. She was a leading actress, four years older than myself. I had met her already during the war and we had become good friends. She was bisexual." Gabriele had been successful in Berlin as a stage actress during the war. Her work had brought her to the attention of one of the leading theatre directors, Jürgen Fehling. Because Fehling had been against the Nazis, "When the theatre started again in Berlin, he was immediately put in charge of one of the large theatres that was still standing. His first production in Germany was

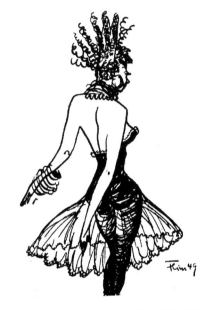

Peter Flinsch (2)

Die Prinzessin

Die Prinzessin, drawing published in *Der Insulamer*, a weekly satirical magazine in Berlin, July 1949.

Drawing published in *Simplicissimus*, July 1962.

going to be *Faust* by Göethe." Gabriele told Peter that when the Nazis closed down the theatres in Berlin, Fehling had said to her, "If I ever open a theatre again, you will be the first I hire." It was this promise that got Peter and Gabriele out of Chemnitz. "When we heard that he was opening a theatre, she said, 'I'm sure this man is true to his word,'" Peter recounts. In order to get out of Chemnitz together, they got married and set off for Berlin.

The local officials had tried to convince Peter to stay, promising him a great future as a people's artist, but, he says, "One could already feel after a couple of months they were closing in. They wanted you to join the Communist Party, of course." This shutting down of freedom was dramatically symbolized in 1953 when Chemnitz was renamed Karl Marx-Stadt, as it would be known until 1990.[7] In 1945, however, getting to Berlin meant access to the West. "Berlin was not divided. It was divided, but only on the map. There was no wall or anything." Taking only what they could carry, they made the journey to Berlin sitting on the roof of a freight car.

Postwar Berlin

In Fehling's production of *Faust*, Gabriele Hessmann played the role of Faust's neighbour, an old woman named Martha, to great acclaim. After she and Peter moved to Berlin, she enjoyed a brilliant career in theatre and film in the late 1940s. In one notable film called *Morituri*, directed by Eugen York in 1948, she played alongside the novice Klaus Kinski in a drama about a concentration camp escape in Poland toward the end of the war.[8] The following year, she played the headmistress of a girls' reformatory in *Girls Behind Bars* (*Mädchen hinter Gittern*).[9] Gabriele also directed a play by early nineteenth-century playwright Heinrich von Kleist, *The Broken Pitcher* (*Der Zerbrochne Krug*), for which Peter designed the sets. He describes her as a very intelligent woman. "It was a friendship, a very good friendship. And it helped us both. It got her to Berlin in good company and she was married. As she was bisexual, this was very good … and it got me to Berlin too. Being with her opened a lot of doors for

7 Marx was, in fact, from the Rhineland in western Germany, not Saxony, where Leipzig and Chemnitz are, in the East.

8 For information, see *cine-holocaust.de*.

9 Reviewed in the *New York Times*, May 10, 1950.

me." Gabriele's career took off in both the Eastern and Western sectors, and she was teaching voice technique at the Berliner Schauspieleschule (theatre school). After a rather short time, however, they divorced, and she subsequently married an American millionaire and moved to New York. Peter found it hard to understand why she didn't continue as an actress since she was so talented. Their paths would not cross again until the early 1970s, at the opening of an exhibition of Peter's work in a New York gallery.

The new life Peter started in Berlin was a fresh beginning, one which would eventually carry him to Montreal. His early adulthood had been blighted by the war, and his ability to come to terms with his sexuality had been damaged by a defining moment of terror under one of the most homophobic regimes in Western history. But getting to Berlin surely brought a burst of optimism, despite all these hardships. Here, Peter began to find his way both professionally and artistically, and eventually, romantically. "From college, I went right into military service. So I never really ever had any free life, you know, like most young men do." He had very little knowledge of gay life beyond his own negative experiences at the hands of the Nazis. He also had no knowledge of the grim fate of homosexuals or others in the concentration camps. "We knew about concentration camps, but not the full extent of it. I mean, an uncle of mine died in a concentration camp, but I only knew it after the war. He was half-Jewish, and half-Jewish people were not supposed to go to concentration camps, but in the later years of the war, he was taken too." Despite the horrors of the past, Peter moved readily into a new life, one that he chose for himself.

In Peter's earliest published drawings in postwar Berlin newspapers, we see elegant gentlemen and ladies like the ones he had done in his now long-ago school days before the world changed. Now there was a decidedly theatrical look to his drawings, reflecting his work in theatre.

Peter never received any further formal schooling, learning his trade on the job. At that time, you could get ahead without the usual German insistence on schools and exams. According to Peter, "If you did the job it was fine. It was wonderful; it was freedom for everybody. And Berlin, of course, in those years—the mid-40s—was quite open and wild!" He worked as assistant to a stage designer, and then got a job designing productions for a small theatre a long way from Berlin, in

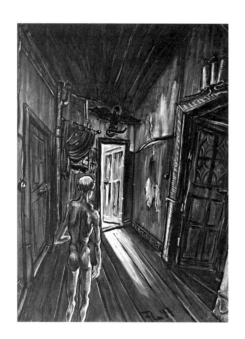

Der Gang / Le corridor, 1947-48, pastel and tempera on paper. The painting was stolen while on display in the lobby of Stadttheatre, Giessen.

Giessen, near Frankfurt, West Germany, in 1947. Flinsch has a photo of a picture he made in 1948 of the view looking down the street from the window of the room where he worked. In the image, "The street was in ruins because part of the city was still destroyed. It is a drawing of what I saw." Another photo shows a painting from the same period called *Le corridor* in which a naked male figure faces away from the viewer. Unfortunately, someone stole the painting from the theatre lobby where it was on display. But now Peter was entrenched in his chosen career. He describes his joy at finding his way into this kind of work. The theatre was "one of the only artistic, creative professions after the war where you could have a career," he says. "And I was in it!"

Peter deployed his talents in other fields as well in the postwar years. He got a chance to publish a drawing on the cover of a book (*Auf der bewegten Erde*, 1946) written by Wolfgang Weyrauch, a young German poet. This was a "poem in prose" that dealt with the experience of a soldier returning after having been a prisoner of war. The publisher thought Peter was a perfect choice to illustrate the book, since he too was a soldier who had returned. In 1950, Flinsch was hired to ghostwrite the "autobiography" of a championship boxer named Conny Rux, who was a big star in Germany at the time.[10] "We first met in his bathtub. I fell in love with him!" Peter's personal copy of this book contains a pasted-in photo of Rux in an alluring pose.

In Berlin, he plunged headlong into gay life as well. "Most of the people I knew were in the milieu, of course. They were actors, dancers, painters, artists, and art students." The social scene was an antidote to what had gone before. "Everybody tried to live it up in Berlin. And really it was interesting because there were representatives of four nations—the French, the English, Americans, and the Russians. Of course, the Western ones all had their cultural attachés and most of them were gay anyway, so it was easy to get around in that time." In this effervescent milieu, Peter met Heino Heiden, the man with whom he would spend the next ten years. Heino was premier dancer at the State Opera and then at the Comic Opera. He and Peter found a wonderful spacious apartment around 1949 and set up life together.

The couple enjoyed an exuberant social whirl. In 1951, they decided to celebrate Carnival in style with a theme party called "After the

10 *Ich schlage mich durch!* (Berlin: Arani-Verlag, 1950).

Shipwreck" where, Peter explained, "guests could either dress up or not dress. You didn't need elaborate costumes. *Au contraire!*" They invited all the painters, artists, and dancers they knew. One friend of Peter's friends, painter Werner Held, brought a distinguished guest, Dr Christian Adolf Isermeyer, an art historian and later director of museums, who was not particularly out of the closet at the time. As Peter recounts, "Later Dr Isermeyer said in his memoirs that this was the turning point in his private life, because he saw all of a sudden how wonderful it was to be openly gay."[11] (When he died, Isermeyer left a significant fortune to the Schwules Museum, the gay historical museum in Berlin.) Looking back, Peter sees that with his present knowledge of the German art scene, the guests were among Berlin's greatest artists of the period, but in those days everyone was still young, and unknown, and free-spirited. "One guest came as the sea captain and he had his boyfriend, who was black, like a slave. At the entrance of the studio, we had a large basin of water so people could sort of splash themselves and come in dripping."

There were two other special guests who demanded invitations at the last minute: Peter's mother and her cousin Erna, a lesbian. Both came dressed as sailors. He said, "She was visiting Berlin from East Germany, but at the time things were still open. It just happened that she wanted to visit and we said that we had planned this party." Of course, Peter had nothing left to hide from his mother following his arrest during the war. His mother said, "Oh great! I'll be at the party, but don't tell anybody that I'm your mother." She and her cousin enjoyed themselves immensely.

Soon after, Heino got an offer from a touring company that was producing a full-length modern German ballet by Werner Egk entitled *Abraxas*, based on the story of Faust. When offered a job as maître de ballet, Heino made it a condition that they had to hire Peter as well. Thus Peter became the props manager for the show. With two good incomes, they made enough money after a year that they were able to move to Paris. "Heino had always wanted to take ballet classes from the famous Russian ballerinas who at the time in the early 1950s were still alive and teaching in Paris." After that, Heino got a job in Munich, and Peter followed him there too, where he found work helping to stage

11 See Sternweiler (1998).

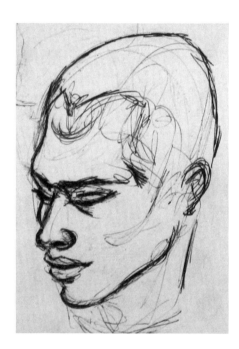

Drawing of Vanoye Aikens, 1953, ink on paper.

Page from Flinsch's scrapbook with souvenirs of 1953, a photo of Flinsch, and a drawing of Vanoye Aikens.

operettas. Following this, Heino was lured to Canada.

"We were friends with a Jewish woman from Berlin who moved to Vancouver," Peter recalls. She told him, "This is such a wonderful country, Canada. It needs people like you—dancers and art and stage designers. Come." She got Heino a job at a ballet school. They were cautious at first, however. Heino went alone while Peter remained in Munich, where he was doing publicity displays for Air France (aided by the fact that he spoke French fluently). They were apart for a year, but Heino's enthusiastic reports of life in Vancouver prompted Peter to join him in the fall of 1953, with a promise from Heino to find him a job in television, which had not yet started in Germany.

During their year of separation, Peter was not lonely, spending as much time in Paris as in Munich. "I could get free flights from Air France all the time. So weekends in Paris were the rule for me." He kept company every weekend with Vanoye Aikens, the tall, handsome lead dancer from the Katherine Dunham Dance Company of New York, then on an extended tour of France. Peter compiled a scrapbook from this period, comprised of photos of the dancers on the streets of Paris, many Flinsch sketches and photos of Aikens, hotel bills, and other incidental documents. The sketches are some of the oldest surviving examples revealing Peter's skill at depicting men in all their complexity; including head shots, profiles, torsos, and nudes (from the back). But soon Peter set out to join Heino in Vancouver, as arranged.

Moving to Canada

In October 1953, Peter arrived in Vancouver. During their short time there, he and Heino had a remarkable experience that revealed to Peter how different his new home was. They met a police officer while out cruising. "In Vancouver, there was a place which was controlled by the police, toilets near the beach. A policeman picked us both up, while we were walking on the beach. He drove us home in the police cruiser. He told his dispatch, 'I'll be off for half an hour.'" Given his own disturbing experience during the war, Peter took this to be an indication that in North America, things were much more naïve. "That was in the time before homosexuality had a name in Canada," he recalls. "At that time, no one gave it much thought. So it was fine to do it."

Their stay on the west coast would be brief. Heino, who was the

artistic director and choreographer of the Vancouver Ballet Company and an instructor at the British Columbia School of Dancing, travelled to Toronto with his company to participate in the Canadian Ballet Festival. There he met Pierre Mercure, Montreal composer and television producer at the Canadian Broadcasting Corporation/Radio-Canada, who persuaded Heino to come to Montreal to work on his television show, which included classical ballet at least once a month. In April 1954, Peter once more followed Heino, and with excellent contacts in television in Montreal, he got a job almost immediately at the network because of his experience as a stage designer in Germany.

Peter and Heino initially set themselves up in a room at the YMCA in Montreal until they found a large apartment to rent on Park Avenue, where Heino had space to teach dance students. Peter began to work on set designs and art direction at the Canadian Broadcasting Corporation/Radio-Canada. Television was still quite new in Canada, and the CBC was a very interesting place at the time, with people like René Lévesque, later the *indépendantiste* premier of Quebec, working as an announcer. "I was fluently bilingual. I worked mostly in French, of course. I knew both languages even before coming to Canada." In this setting, he quickly learned his way around. The young couple quickly made their way in the gay world as well. One closety phrase Peter picked up at this time was calling a gay man a "friend of Mrs King," a Canadian variant on the well-known gay expression "friend of Dorothy." Mrs King was a reference to Canada's former Prime Minister Mackenzie King who remained a bachelor all his life and lived with his mother until she died.

Connecting with Montreal's gay scene was easy for the new arrivals. Radio-Canada was notorious in the 1950s for hiring homosexuals and had acquired the nickname Radio-Tralala, so Peter would have immediately met other gay men through his work. In Montreal, he and Heino found a more developed gay scene than they had encountered in Vancouver, but "not quite as much as in Berlin." Montreal's gay world was then divided in two, with the more upscale bars, especially the Tropical Room on Peel Street, in the Anglo "downtown" in the west, while the more Francophone focus in the cast was in mostly mixed (gay/straight) clubs in the old Red Light area, the Main, brilliantly portrayed in the theatre and fiction of Michel Tremblay. The city's cultural duality

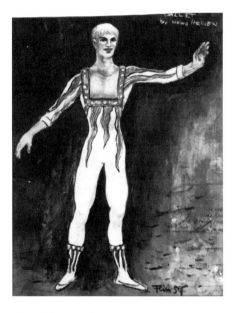

Flinsch drawing of a male dancer's costume for *Evocation to Apollo*, Heino Heiden, Vancouver Ballet Company, 1954.

PETER FLINSCH

L'ANNÉE BLEUE

PEINTURES DESSINÉES

VOUS ÊTES CORDIALEMENT INVITÉ À L'EXPOSITION DES OEUVRES DE
PETER FLINSCH, À LA SALLE PAPINEAU DE LA MAISON DE RADIO-CANADA,
LE 14 NOVEMBRE 1978, À 16 HEURES. L'EXPOSITION SE POURSUIVRA
JUSQU'AU 1ᵉʳ DÉCEMBRE, DU LUNDI AU VENDREDI, DE 10 HEURES
À 18 HEURES.

RELATIONS PUBLIQUES, RADIO-CANADA, MONTRÉAL

Exhibition invitation for "L'année bleue," 1978,
Radio-Canada.

was premised on a class difference and a geographic separation in the
popular imagination, yet everyone knew that on the ground there was a
lot of crossing of those boundaries; this was most especially true of the
gay world.[12]

Peter and Heino regularly visited the only exclusively gay club in
the Red Light, the Monarch Café, popularly known as the "Zoo." "We
always enjoyed the Monarch because ordinary men went there, which
I enjoyed very much." Once a year, the Monarch was the centre of all
attention. "On Halloween, they had a ball and a dance, and partygoers
arrived *en grand style*. People gathered outside to watch them. Cleopatra
and Marie-Antoinette were the favorite costumes. It was incredible."

They also went to the Tropical Room downtown and, on Sunday
afternoons, the Hawaiian Lounge on Stanley. Peter particularly
remembers the places where Armand Monroe was the host, the Tropical
starting in 1957, and then the Lutèce on Crescent Street in the early
60s. "There was a very warm, family atmosphere in those places—sing-
along stuff and all. Quite wholesome, as a matter of fact."

Looking at a picture of Montreal's glamorous clubs and theatres on
downtown Ste-Catherine Street in the late 50s, Peter exclaims, "Look,
the infamous Palace [cinema] with the freehold toilets! People went
in the afternoon for the two o'clock show because it was said that the
guys from the office went there for a quickie." Another shot reminds
him of the famous Montreal Swimming Club, an all-male institution
on St Helen's Island just off downtown Montreal. "It was infamous.
Of course, we had sex in the toilets and in the bushes. We swam, and
there were floats where you could jump in the water. It was wonderful.
Before we had a car, we walked all the way across the bridge on Sunday
afternoons." Meanwhile, Peter and Heino's relationship evolved over
the time they were together in Montreal. "We developed an open
relationship. I don't believe in drama in my life. I don't enjoy heavy
arguments and screaming and stuff. I want things easy." That meant
that it was all right to bring someone else home for sex.

They also went much further afield, visiting the gay mecca of
Provincetown in the 1950s. "Long, long ago," Peter recounts, "when it

was sort of a quiet, quaint, queer town. There was this wonderful piano

12 For a history of Montreal bars during this period, see Higgins (1998).

bar. On Sunday afternoons, a pianist from Boston played show tunes and everybody sang along. It was a wonderful time." Later, Peter would also visit San Francisco, as well as travel regularly to New York and Germany.

They soon found a wide-ranging social world, not only gay but very inclusive. "I always enjoyed, and I still do, mixing people: people from all walks of life, people who prefer a beer and hot dogs and some who would rather have smoked salmon and stuff like that. But they all have to be entertaining, you know. You have to add something to the party, not just a name."

Unlike some other men who were part of Montreal's early gay community, Peter felt no need to hide.[13] He had nothing in common with those who always took care to avoid being seen as two men or three men together at the theatre or a restaurant, closeted gays who found women to use as "beards" for such occasions. "I was quite open," he says. "I mean, at work I didn't say 'I'm gay.' I didn't have to say that. But it never came into question. So I never really needed women for cover." Few professionals worked in environments like that at the time, so, together with his experiences in the war, it provided another strand in his independent attitude about sexual identity. He also read the Kinsey Report on male sexuality published in 1948 ("It was part of my late education and part of the healing process for my old wounds") as well as some of the new gay publications that had reappeared in Germany (where numerous papers were suppressed when the Nazis came to power in 1933), including *Die Freundschaft* and *Der Kreis*, a Swiss publication that was the only such magazine to be continuously published since the prewar period of gay organizations. "But I guess I was too busy making a career working and experiencing things myself. To read about it comes later in life. You read things and go 'Oh yes! I did the right thing.'"

At the end of the 1950s television had changed, and Heino no longer felt he could work as seriously in dance at Radio-Canada as he had at the beginning. "He had done everything he could do here," Peter says. Heino got an offer at a very good opera house in Germany

13 My dissertation (Higgins 1997) was based on interviews with thirty men about Montreal's gay culture before 1970.

and he took it.[14] This time, Peter did not follow along. "This ended our relationship, of course. His profession was the most important thing to him, and I was very happy here in my job, so there was no reason for me to leave." Heino signed a long-term contract in Germany in 1960. The breakup was difficult, but they managed it amicably. "I see him every time I go back to Germany. We are still very good friends." Heino would later help Peter with an early exhibition in Germany at a gallery he set up in a ballet school in Lübeck.

After Heino's departure, Peter moved to a smaller apartment closer to his work downtown. He had lived in an old house until 1968, when he moved into a high-rise apartment with great lighting and space. He continued to explore Montreal's gay scene and nightlife, including exotic haunts like the Neptune Tavern, a vestige of the old waterfront life, full of unemployed sailors and publicized as a gay hangout in an early gay tourist magazine feature on Montreal.[15] Another club was Chez Rudolf (a name that has not come up elsewhere in my research, but that does not mean it never existed). Few would have known about it, given its pretensions. "The bar was piss elegant, in white and gold. There was always a beautiful black man in white tails playing the harp. How elegant can you get? You had to be a member, of course." By the mid-60s, the number of Montreal establishments exclusively catering to gay men was on the rise, so there were many such ventures.

Peter met a wide range of artists, including German-speaking painters like Karl May, an Austrian Expressionist. May lived with his wife in the Laurentian Mountains north of Montreal. Referring to his own affinities with Expressionism, Peter observes, "Mostly artists associate with others working along in the same spirit." Not all of these men were gay by any means, but they all seemed interested in Peter's work, and, confident in his skill and insight, they posed for him and collaborated on artistic projects. Artist-models include Gilles Dorais, seen in Plate 15, *Gilles D*. The small group of artists with whom Peter exchanged portrait sessions stands out from the broader range of the artist's friends, who were never drawn, never part of the visual record of the world he was making. Only much later, with much younger

14 To assist with the world premiere of a ballet by Paul Hindemith, *Noblissima Visione*, in Mannheim-Ludwigshafen.

15 *Ciao!* (May 1973).

artists than himself, did Peter form a more regular circle of gay artists, including Claude Bibeau and Daniel Barkley, who worked in entirely new ways of representing the male form, gay sexuality, and queer sensibility. As Peter says, "They are generations younger than I am. They are much more free to do what they really want." For the younger men, with few older gay artists to look up to, Peter Flinsch's steadfast courage and determination in pursuing his trailblazing artistic projects must have helped pave the way toward that freedom.

Around 1960, shortly after Heino left, Peter bought a car and travelled the countryside. One place he discovered was Meech Lake, near Ottawa but on the Quebec side. "There was nude swimming and bathing. Later, they put a sign warning: 'Proceed at your own risk. You may encounter unclothed bathing,' or something like that. With this sign, everyone knew exactly where to go ..." Peter made other forays into the countryside to visit friends, as well as trips he made with Alan B. Stone, the physique photographer mentioned earlier, and several of his male models. Some of the footage in the documentary *Eye on the Guy* was taken on outings to a property near Lachute in western Quebec owned by Peter's friend Bernhard Diamant (a very prominent Canadian music teacher). Later, Peter visited another nude swimming spot at St-Jean-de-Matha, Quebec, which had a gays-only section in the 1980s and 90s until it was turned into a provincial park.

Drawing Men
After Heino's return to Germany, Peter had more time and opportunity to devote to his developing passion for drawing men. "After moving to Montreal, I started to paint regularly, because my day job allowed me free time at home. It's been my full-time profession since I left the CBC in 1985. I became an artist as a result, because if you can do it without interruption, the results will be better; more satisfying for yourself and others too."

Peter drew images of men throughout the 1950s, but not in large numbers, because his energies were focused on his developing career in TV set design and the busy social life of a handsome, young, gay Montrealer about town. By 1960, there are more and more pictures. In his artwork, men come alive on the page and canvas, the result of either live sessions with models or through the artist's own imagination. They

are on the beach, in the reeds (a recurring image), at wrestling matches, in the shower, the sauna, or in bed.

During the twentieth century, a current of popular gay art developed that has attracted little notice by mainstream art historians. Much of this work was considered simply too obscene, too obviously pandering to lowlife taste to be taken seriously as legitimate artistic expression. Technically, it is true that a lot of the artwork was not overly sophisticated. But then along came the art of Peter Flinsch.

Models, Snapshots, & the Imagination
Gifted with a mastery of line and colour, and having been exposed at an early age to the uncensored art of great masters and the experimental German movements of the twentieth century, Peter made an artistic commitment to the representation of the male form. His work speaks in an artistic language of his own making, which draws on the visual idioms of German Expressionism and the New Objectivists of the 1920s, when he was a schoolboy living in his grandfather's house in Leipzig. One of the benefits of being an artist who specialized in the depiction of male bodies was that it meant spending long hours gazing at handsome men with beautiful bodies. With unparalleled sensitivity in his artistic portrayals, Peter delves deep into the politics of the gaze—that of the artist gazing at his model, and of the model gazing at both the artist and the viewer. In the 1950s and 60s, men in North America were not normally subject to the gaze unless they belonged to racial minorities that made their bodies fit for scrutiny and control. There was also always the possibility of the gaze in the sports arenas where male athletes showed off their physical prowess as well as their bodies. Here, the male body is seen at its full physical potential, and thus is deemed worthy of being seen. At the same time, weak and vulnerable aspects of masculinity are being kept out of view in mid-twentieth-century visual culture, as commentators such as Thomas Waugh, Richard Dyer, and Kobena Mercer have pointed out. Through his art, Peter pulls back the curtain and takes us into the intimacy of male lives which artists would begin to explore in greater numbers only later, following paths marked out by pioneers who once faced ostracism and even arrest for making the eroticized male form a subject of artistic exploration.

The relationship between artist and model has long been a source

of fascination. Going through Peter's sketch books with him, I could almost see on the unfurling pages how the afternoon light advanced in the studio as picture after picture was made. The model relaxes on the posing stand as he and the artist get down to work. The mood of the artist shifts as he picks up pastel, or ink and pen, then perhaps switches to brush. In one session, five or six very different works can take shape, all of which show a man, his body, and his thoughts about himself and his body. Some models clearly join in the project, sensing what the artist sees and why. Those who posed for Peter early on knew it was rare for men's bodies to be shown in this way. Peter's favourite models were men who were at ease with their bodies, athletes and dancers who had no problem revealing what they had trained and practiced so hard to achieve. "My relationship with the model is always very close." Peter says. "It's a creative relationship. I have to be inspired and I have to like the person. Sometimes ideas for a painting come from working with a particular model, like the large painting of a street hustler and a beggar on St Catherine which I did last year."

Some came back to pose repeatedly, like University student athletes Gene and Ralf, the always joking model for the "Rainmaker" series, and the beautiful Roland Smith. Most models stuck around for a brief month or two; then they are seen no more. Others stayed for many years in the artist's life, especially Ray, Ben, Clifford, and a few others, becoming friends for life. As a result, we see their bodies maturing, their faces changing with the decades. Many of these men were not gay, but simply enjoyed posing. Gene and Ralf came regularly for a while, judging by the number of drawings of them that were done. Plates 10 and 11 hint at the complicity between them and the artist, which is even more apparent when one sees the multiple images from the same series. There was a succession of many such models through the artist's studio for over three decades.

Some models' lives were cut tragically short, the loss particularly apparent in the vivid images of Ray Artuso and Roland Smith, both extraordinary models whose complicity in the creative act is manifest in every drawing. Peter was especially fond of Ray, who worked at the counter of the YMCA; his sports were Greco-Roman wrestling and handball. He estimates that he must have at least twenty or thirty sketchbooks filled exclusively with pictures of Ray. Plates 3, 6, and

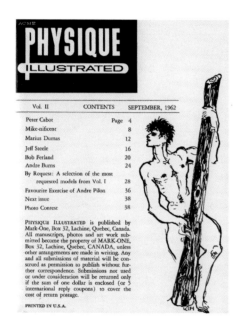

PHYSIQUE ILLUSTRATED is published by
Mark-One, Box 32, Lachine, Quebec, Canada.
All manuscripts, photos and art work sub-
mitted become the property of MARK-ONE,
Box 32, Lachine, Quebec, CANADA, unless
other arrangements are made in writing. Any
and all submissions of material will be con-
strued as permission to publish without fur-
ther correspondence. Submissions not used
or under consideration will be returned only
if the sum of one dollar is enclosed (or 5
international reply coupons) to cover the
cost of return postage.

PRINTED IN U.S.A.

Physique Illustrated, vol. II, September 1962,
drawing by Peter Flinsch.

22 show a fragment from the full range of this work, which reflects
the relaxed attitude that united the two friends. In Peter's dining
room, there is a beautiful small statuette of Ray, naked and reclining
(Plate 109). The two visited Italy together and clearly spent a lot of
time in each other's company. As for Roland, he was a man who posed
professionally for art classes at Concordia University; while only in his
thirties, he suffered a fatal asthma attack.

I mentioned to Peter that Montreal gay photographer Carlos Quiros
once told me that getting intimate physically with a model could have a
negative impact on one's work, and he agreed. "As a result, sometimes
I stay away from it, even knowing that it would be easily possible."
Significantly, most of Peter's lovers are absent from the sketchbooks.
Though Heino is seen in many photos from throughout their more than
fifty years knowing each another, I have not seen a single drawing of
him. While some models became friends, few friends (or lovers) became
models.

Whenever Peter left the downtown gay clubs in the evening, his
way home took him along the busiest part of Montreal's main east-west
thoroughfare, Ste-Catherine Street. Sometimes these trips resulted in
new ideas for drawings or paintings, as well as meetings with potential
models. Looking at one image, Peter says, "I think I saw this guy lying
on St Catherine during the night." I protest that the man was nude and
the picture was dated March 17, a chilly time to be naked on a Montreal
street. "Well, he was not quite naked, but almost. I think he was scarcely
dressed; in my memory I made him naked, of course." Even at the clubs,
Peter sometimes managed to recruit models. One man, the subject of
Plate 26, "Steve Jean," worked as a waiter in a bar in the Village and did
some house cleaning for Peter. Another model was brought to Peter by
a photographer friend, John Brosseau. Plate 14, *Chico Cubano*, shows a
young man who, according to Peter, "didn't speak a word of English, but
was very pretty."

Fit Bodies, Erotic Bodies: Dancers & Athletes
From training sessions for participants of the 1976 Montreal Olympics
to more recent sketches of rehearsals by members of Cirque du Soleil,
Peter has long documented the kinetic imagery of sports and dance.
Some of these are quick sketches, suggesting movement in space without

much detail. Others are more complex, vivid snapshots of rehearsals, wrestling matches, or bodies at rest after exertion.

As a result of his relationship with Heino, Peter naturally spent a lot of time socially with dancers. But his interest in dancers' bodies was not limited to men. In fact, his work could take viewers on a tour of many aspects of the dance world, especially the behind-the-scenes, spur-of-the-moment sketches of rehearsals, of both male and female dancers in repose, as well as on stage performances.

Peter had a remarkable experience when he documented the work of one male dancer in particular: dozens of drawings based on the performances of Japanese dancer Min Tanaka on the grand staircase inside the Montreal Museum of Fine Art in 1980.[16] "He came down the stairs almost completely nude and painted in heavy, earthen-coloured makeup so he looked like a statue made of brown earth or something." For Peter, it was an opportunity to draw a body in spectacular shape. "When I first saw him I said I must come and draw him. He couldn't speak English or anything." Plate 16, *Tanaka, the Japanese Dancer*, shows a large oil painting based on this series of sketches.

Later on, through his extensive contacts in the dance world, Peter was often a guest at rehearsals for Les Ballets Jazz de Montréal, Les Grands Ballets, and more recently Cirque du Soleil; he once sketched during rehearsals when Alvin Ailey's company was appearing in Montreal. At times he drew on distant memory for his dance pictures, such as a sketch he did of a production of *L'amour parfumé*, in 1995, a dance number he saw in Paris in 1953!

Flinsch's best source of models was the local YMCA, where he swam regularly. There, he put up a sign on the bulletin board asking for people to pose, using the phrase "serious academic painter looking for models" to avoid doubt about his motives. One young man was so keen to pose that he lied about his age. Peter had specified that models should be eighteen, and eventually realized that Ben was only sixteen. That relationship was never sexual, since Peter had a jealous boyfriend at the time and he saw that Ben was far more interested in him as a father figure, filling an absence in his life. Peter also met the boy's mother,

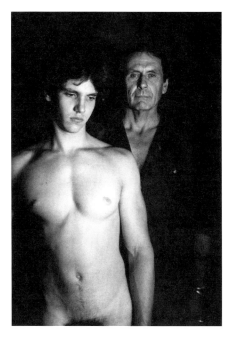

Peter Flinsch with Ben, by Marcel Fugère, ca. 1980.

16 Min Tanaka press release by Telbec (March 15, 2005)
(*communiques.gouv.qc.ca/gouvqc/communiques/ME/Mars2005/15/c4939.html*, accessed Jan. 21, 2007).

who came to the studio to see what kind of work he did, although she wasn't particularly protective of her son, whom she often sent out of their home to wait in restaurants while she entertained boyfriends. Ben was an athlete in excellent shape, and very handsome. Plate 4, *Ben B*, is just one example of the many extraordinary drawings Peter made of this model, who ultimately left Montreal after they had known each other for several years.

Peter's bulletin board notice was so successful that soon men came to his studio because they knew someone else who had already posed. Many sketches simply bear first names only. *George*, the title of one not included in this selection, was a wrestler at the Y known as "Big George." Ray Artuso, mentioned above, who became one of Peter's closest friends, was another wrestler, and there are many gym scenes like Plate 37, *School for Wrestlers*, and portraits such as Plate 42, *Napier, USA, Wrestler*, among the drawings in Peter's sketchbooks.

Looking back, Peter said he made more friends at the Y than in gay bars. "The YMCA is a social club. Most people who go there meet other people and they talk." Sometime in the late 1960s, Peter noticed a particularly handsome man at the Y on numerous occasions, but never talked to him. One day a friend of his said, "I have seen the most beautiful man at the Y! You should paint him. I've already talked to him, and he may be interested in posing for you." Of course, it was the man Peter had noticed earlier. It turned out that he was a leading water polo player. He came to the studio and they hit it off immediately. Plate III, *The Swimmer*, shows him in diving position; their friendship, which continues to this day, led to Peter sketching numerous other water polo athletes. Another player appears in Plate 1, *Body by Chase*.

Through his water polo connections, Peter was also able to develop an extensive body of work on swimmers. In 1976, the year the Summer Olympics took place in Montreal, he made portraits of many members of the Canadian men's swim team. Through this network, Flinsch met Victor Davis, the 1984 Olympic swimming champion, who sat for several works by Peter, both in painting and sculpture. When Davis died in 1989—struck down by a car driven by someone he had allegedly had a heated argument with—at the young age of twenty-five, Peter reworked an oil portrait, turning it into a memorial which was presented to

Davis's father. The artist's personal collection of sculptures includes a large bust of Davis.[17]

The 1976 Olympic Games in Montreal were a golden opportunity for Peter, who already knew members of the Canadian water polo team. He was able to observe the practice sessions of many different sports, and filled up multiple sketchbooks as a result. In the 1980s, he met Michel Prévost, a boxer and future Olympian, whose father had a gym where Peter went to do sketches of him. Plate 59, *Shadow Boxer*, was drawn in 1996 and is perhaps a remembrance of those days. From the 1950s on, Peter regularly attended physique and weight-lifting competitions, boxing and wrestling matches, and many other kinds of sporting events, which inspired many drawings and paintings, as in Plate 43, *Clean Press*. On some occasions, he would sketch on the spot and then add colour and detail later. Some of his pieces were executed with a high degree of abstraction, at times long after the event that inspired it, such as the stylized work of Plate 58, *Hand Ball*.

Apart from sports activities themselves, many other sports-related scenes flooded the artist's visual imagination, and reflected his keen observation of the rarely documented nether worlds of male-on-male sociability. In Plate 38, *Nach dem spiel (After the Game)*, Plate 40, *Locker Tales*, and Plate 61, *Wrestlers Resting*, guys sit around naked in the locker room discussing the game (and looking each other over). The desiring eye is even more active in saunas, where, in Peter's pictures, men do nothing but sit around admiring their companions. Plate 36, *Le bain juif (Colonial)*, shows one of the city's classic Jewish schvitz baths, which also has a long history as a gay meeting place.[18] Plates 44, *Sauna Corner*, 47, *Sauna*, 56, *Sauna 180 Degrees*, and 57, *In the Steam*, reflect the iconic status of such facilities.

In addition to all the athletes, young men from Peter's home country of Germany who were passing through town were often coaxed into posing. Colleagues at CBC were another source of models, whether they posed or not. Plate 72, *Henri et 3 hommes*, depicts a man who was a painter there who never came to Peter's studio. When the television station

17 Alan B. Stone took pictures of Flinsch at work on this sculpture in 1986, now in the collection of the Archives gaies du Québec.

18 One of the men who shared their life experience in gay Montreal for my PhD research was arrested there in 1962 (Higgins 1997).

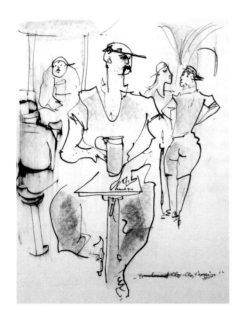

Franchement, Clo-clo, t'exagère[s]!, 1991, pen and ink, washed, 35 x 27 cm. Courtesy of Ross Higgins.

moved to the eastern part of Montreal, Peter started to ride the Metro to work every day. There he had ample opportunity to study humanity in all its various forms. He would memorize faces, bodies, and postures, then rush home to get them down on paper, making true his frequent repetition of the line, "I am a camera."

Peter's friend and local peer in the representation of male figures, physique photographer Alan B. Stone, proved a good source of models as well. Peter found it hard to reconcile Stone's reserved personality with his success in finding men to pose. "I was always surprised because his models were always interesting and sexy people." Peter's friend André (Plates 9 and 33) was one of Stone's featured models in the early 1960s. We see him in footage from Stone's 8 mm films driving Peter's Jaguar. He and Peter remained friends for many years. Mike Mangione, a well-developed young bodybuilder who was one of Stone's biggest stars, also came regularly to pose for Peter.[19] And Johnny Kent, an American of Hungarian origin, came to Peter's with Stone for a photo shoot in the 1980s.

Sometimes models would be inspired by the experience and want to try their own hand at drawing. Peter's sketchbooks preserve, scattered among the thousands of his own drawings, a handful of work by André, Len A., and others. "Ben made a naked drawing," Peter says, "and he signed it Flinsch!" The only one whose talent Peter really praised was Len (see Plate 13, *Len*): "He was gifted, no doubt about it. He was a true naïve painter." One of Len's pictures was a less-than-convincing portrait of Peter himself.

Peter portrays sexual activity in some of his paintings and drawings, though most merely suggest sex. Sometimes, however, he set out to document the sex act itself. On several occasions after he retired from his day job, he had couples come to his studio and make love on the bed in the corner while he sketched away. He did not just do this with gay men, but with heterosexual couples as well.

Despite the numerous model sessions, however, many of the men in Peter's work are not drawn from life, but resided only in the artist's imagination. He quotes Albrecht Dürer, one of his favourite artists,

19 Flinsch decided to donate all the pictures of Mike Mangione to the Archives gaies du Québec, which totalled twenty-four drawings just in the portion of the sketchbooks I examined for this project.

38

who was once asked if he had made a particular picture with a model and he responded, "A painter must be full of figures inside." With all the people who passed through his studio and the vast urban masses he observed as soon as he stepped out of his downtown apartment, Peter had stored up an inexhaustible repertoire of human faces. In his work, the face is often the most powerful aspect that draws the viewer into the picture. A small, carefully wrought face is often the focus of a human figure that is otherwise only sketchily delineated.

Flinsch and his mother, visiting from East Germany, 1961.

Imaging the Gay City

A major theme throughout Peter Flinsch's career has been the urban gay world that he inhabited. His work in this series shows men in various locations in Montreal's gay scene, including the YMCA, taverns, beaches, and streets. In these pictures, Peter offers a sympathetic but slyly ironic commentary on the fashions and foibles of cruising. The depictions range from documentary to iconic fantasy or even caricature. His gay imagery includes evocations of the past, including several visual allusions (and homage) to poet Walt Whitman in Plate 91, *Walt's Boy*, and to novelist Yukio Mishima (in a portrait not included in this book). But his main focus is present-day gay life, tin Montreal, specifically the human interaction that takes place in the new public arena of the city's Gay Village. Plate 48, *Talk Me Into It*, captures the pick-up scene in a multi-layering of arms and faces. Plates 82, *Words*, and 85, *The Frisco Kid*, show the contrast between being with someone and being on your own. Like his friend Alan B. Stone, Flinsch also liked to capture random moments in men's lives. One such image is Plate 73, *In the Bicycle Shop*, where a cute repair man (presumably gay) is caught in mid-motion hanging bike wheels on a rack.

His work sometimes takes a hard look at the multiple cruelties and disappointments of the gay cruising scene, in Montreal or anywhere. He charts the various interactions between the beautiful and the plain, the old and the young, the size queens and the well-endowed, moments frozen in time in which the artist reveals his admiration, his amusement, and, indeed, his sadness (many were done during the period when the AIDS crisis was at its worst). Flinsch's imagination was ignited by the looks and gestures of local gay men on their own turf, enjoying unprecedented new visibility in the Village.

Peter has portrayed the Village in his work since its origins in the early 1980s. He has an insider's eye, but with the slightly sardonic twist of an onlooker who has been out since before he came to the city in 1954. Montreal's old gay centre was downtown, but subsequently moved east to the predominantly French-speaking section of town. This was further east than the old gay scene of the Main, mentioned above, populated by lower-class Francophones and Anglophones as well as middle-class "tourists." (Now the centre of gay life in the city has moved radically east.) Part of the joy of observation reflected in Peter's drawings is how he documents these cultural shifts, not only the French/English dynamic central to Montreal life, but the increasing diversity as the city's population changed with new arrivals from Europe, Haiti, Asia, Latin America, and the Middle East. He scrutinizes these newcomers and their diverse ways of performing masculinity off stage and on, and the development of a part of town where homosexuality is visible and public, with loving, detailed attention.

Two night spots hold particular attention for Peter: the Taverne du Village (Plate 30), where summer after summer for a few glorious years in the 1990s the management completely reworked the visual scheme of its street-level terrace from a hot dog stand to a cruise ship, and Campus (Plates 50 and 51), one of the dancer bars known for its chiseled, well-defined performers, with heterosexual written all over their muscular bodies. Customers and staff at both establishments get skewered in the artist's humorous gaze. In pictures that sometimes evoke public scenes done by Expressionist artists like George Grosz, Peter focuses on interaction, on moments of conversation and gesture that evoke a visual language shared by gay spectators everywhere. In the dancer bar, Flinsch's performers are our contemporaries, guys stripping for guys, gay or gay-for-pay whatever their real sexual orientation. There is the familiar swagger, the straight boy contempt for the fag, and the knowing laughter of the fags at the tables lapping up the performance. Peter also documented some of the other customers at Campus on Ladies' Night (Plate 34). According to him, "The boys don't like ladies' night because the ladies never take them to the back for a private dance. The ladies are cheap!"

Flipping through hundreds of Peter's sketches, one gets a full sense of Peter's vivid depictions of gay culture. Each image is a moment,

part of the kaleidoscopic mosaic of gay men in their own social world. There is an extensive series of gay scenes at the beach, usually full of bulrushes, which the artist admits he values for their phallic impact. Examples in this collection range from Plate 79, *Sand in My Eye*, done in 1966, to Plate 67, *The Tan*, from 1992. The dynamics of gay relationships is a recurring theme too. Lovers sometimes appear rather sad; in many pictures they are positioned back-to-back, in scenes suggesting jealousy or disagreement like Plate 84, *Il pleut* (It's raining). At times three figures are shown, with two rejecting the other (as in Plate 60, *Nobody Loves Me*), an aspect of gay relations documented with zest and irony. Even some titles are meant to amuse, despite the suffering depicted. One ménage-à-trois scene (not included in this book) has three titles: in English, *Three Is a Crowd*, and in German, *Drei sind zuviel* (Three is too much); in French, it is *Pas de trois*, which could mean either "No threes" or a dance with three partners. Many pictures also have an inscription (sometimes entire paragraphs) in Latin as well as in the three modern languages Peter actually speaks, reflecting a joyous exuberance of linguistic as well as artistic expression. Not all his themes are ironic or sombre. In Plate 91, *Walt's Boy*, there is a sexual tension, an expectation of what is to come between the old poet and the young man at the table. Though the figures in Plate 46, *Look Back in Joy*, are positioned back to back, the two men have just had sex, we may assume, and the one in the foreground is looking wistfully back at someone he will probably never meet again, given the harsh realities of the gay scene, the bittersweet nature of the quickie. Much more positive is Plate 86, curiously titled *Unfinished but Complete*, which shows two men in complete synch with one another.

A Wide-Ranging Visual Sensibility

The selection of drawings in this book gives readers a small glimpse into Peter Flinsch's immense artistic output. The limited number of works, including line drawings and coloured wash, along with many more elaborate techniques, will have to represent the enormous range of his studies of men's bodies in repose and in action, his sketches of gay life in Montreal and elsewhere. But in fact, Peter's work extends far beyond those central themes.

Other pieces record his various travels, including scenes observed

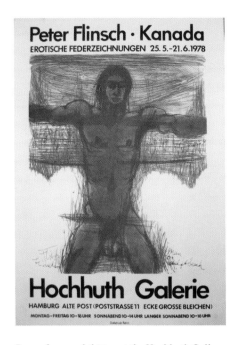

Poster for an exhibition at the Hochhuth Gallery in Hamburg, 1978.

on the streets in Africa, as well as the Grolos—little round people in comic situations, a sort of cartoon expression of the futilities and frustrations of daily life in the modern city. Landscapes, both realistic and imagined, also make up an important part of his work. But even in other genres, Peter has always remained close to the human form; he affirms, "I believe in the word of William Blake who said, 'In every landscape is a human form.' He saw the human form everywhere." Another type of picture I have termed "Mysteries" includes ethereal images of the moon, birds, human supplicants, and the like. They draw from a visual vocabulary of spiritual symbolism that is well known but not usually seen in a gay perspective—the supplicants here are handsome men with attractive, sexy bodies.

Given his training by professional artists when he was a teenager, Peter had absolute confidence in his ability to handle virtually any artistic technique. Being extremely prolific, he was not dissuaded by failure, and continued to elaborate upon a variety of styles and techniques over several highly productive decades, beginning in the mid-1950s. When questioned on the difference in his technique from the line drawings done earlier for Stone's physique magazines to those done in the 70s or later, he says, "I got much more free with the years." He also developed a method of varying line thickness, leading to two distinct styles in his line drawings, both of which became even more complex because of the use of washes in the background. This range of modes of his artistic expression is surely one of the strongest signs of his talent.

Peter has worked extensively in simple pen and ink or brush and ink, sometimes combining colours. He has also frequently used pastels and watercolours, alone or in combination with ink, gouache, sanguine crayon, and even ball-point pen. "When you put a fixative on it, it starts bleeding. It becomes very dark, a very strong blue, and I like that. And you can control it. The more fixative you use, the more it bleeds." Some of the sketches of American dancer Vanoye Aikens, whom Peter knew in Paris in the early 1950s, are splendid examples of this technique. In recent years his pen of choice has been the micropen, which he has often used with watercolour because it does not bleed since it is not water-based. Another favourite technique is the use of washes. These could be in any colour but are often a tell-tale brownish-yellowish tone,

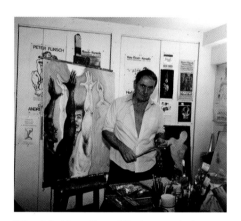

Flinsch in his studio, 1986, photographed by Alan B. Stone. Courtesy Archives gaies du Québec.

thanks to—coffee. "I take my big pot of coffee with me when I start in the morning," Peter says. "And then when I want to wash, I pour some of my coffee in." He produced mottled effects by using tissue paper to sponge up some of the paint while it was still wet. "One can control it, of course, by pressure and a little rubbing. It gives a very nice sort of texture, body to it."

In sculpture, Peter has produced works ranging from tiny statuettes and plaques to imposing pieces like that of Victor Davis mentioned previously, done in wax, or the much earlier *Rise and Fall*, for which Ray Artuso was the model. The artist experimented with the use of Polyfilla, a commercial plaster, moulded and then painted with colours or with bronze or gilt paint. Plates 109 to 112 show examples of these, ranging from small to much larger sculptures. His vigorous depiction of an athlete, *The Swimmer* (Plate 111), is over half a metre tall (one-and-a-half feet) and, remarkably, designed to stand independent of any support. Modelled on one of Peter's water polo friends, it condenses all the raw power of the athletic male body about to launch into action. Many small sculptures are cast in bronze, which the artist had done at a foundry in rural Quebec. His sculptures include both male and female subjects, mostly nudes. A good display of them can be seen in a 1986 film by Ingrid Zwätz, simply entitled *Peter Flinsch*, featuring scenes from an exhibition in Düsseldorf where there were numerous sculptures as well as paintings on display. Peter's notebooks contain a lot of documentation on his sculptures in addition to his paintings and drawings. Most sculptures are human figures, but one comment written in a sketchbook noted cryptically, "Make painted toilet bowl." As Peter explains, "It's a reminder to myself that I should paint the toilet. I said I wanted to do a toilet bowl as an amphora, so Claude Bibeau found one in a scrap yard for me." The finished work graces the sideboard in his dining area. Although sculpture was not a major vehicle for Peter's artistic expression, his masterly handling of its technical and aesthetic requirements is another testament to his overall talent. And of course, many of the sculptures have a rich sensual appeal, like so many of his drawings and paintings.

Peter's pictures almost always have titles, and as noted earlier, sometimes more than one, in multiple languages. The titles range from the simple Plate 47, *Sauna*, or Plate 89, *White Socks* (for a man in

Flinsch's studio, 2006, photographed by Ross Higgins. The painting of the large face is entitled *The Rainmaker*.

Sketchbooks piled high in the closet in Flinsch's studio, 2006, photographed by Ross Higgins.

white socks), to the esoteric Plate 99, *Il ne faut pas cueillir ce qu'on n'a pas planté* (You can't harvest what you haven't planted). For some time, Peter was in the habit of signing his work with the name "Flim." He explained that he actually had a hyphenated name, Flinsch-Maurer, which was the source of this signature. When he published drawings in Alan B. Stone's magazine *Physique Illustrated*, he wrote over this signature so that it became "Kim." It was not, however due to any perceived danger over his sexuality. "No," Peter replied when questioned, "it was just a signature. I never cared to be discreet."

Looking over his work, Peter Flinsch often refers to his sketchbooks as a kind of journal, a visual record of his life and observations. He says, "Many of these books are to be looked at like diaries. Sometimes I put something in it every day, and then not again for a week or a couple of weeks. It's not an actual record of events, but rather themes and things which go through my mind's eye. I think I should call it a visual diary."

Regular sketching gave him ample opportunity to experiment. Looking at one of his smallest sketchbooks, Peter says, "In these small ones I tend to be more adventurous in style and colour. The format lends itself more to doing something on the spot." Since most of his work, or at least the sketchbooks themselves, are dated, it is possible to see that he could make anywhere from two to ten works in a day. Despite being small, work like Plate 103, *I Am the Answer to a Virgin's Prayer*, has been constructed as a complex set of layers of various media; sophisticated technique in service of wry humour. He is very clear about learning from mistakes. "Sometimes I find that I have added colour by mistake. It's not always to the advantage of a piece to add colour, but it depends. Nonetheless, it should be treated in the same manner—lightly." A light touch is one of the hallmarks of Peter's style.

The History & Politics of Picturing Men

The overall effect on the unsuspecting visitor to Peter Flinsch's apartment is one of stupefaction. My first encounter came when I was invited to a party at Peter's around 1990; I found myself in a room with more penises per square foot than I'd ever seen. In the living room, there is little of Peter's own pictorial work. Instead, we see many paintings given to him by friends and a selection of his sculptures in bronze, ceramics, and wire. One of the most spectacular works in the room is a larger

than life-size sculpture by Paul Colpron of Peter's friend Gilles Dorais in full glory. Visible from the door, the sculpture warns the unwary visitor that they are venturing into another world. In the studio itself, not visible from the living quarters, are racks filled with oil paintings. But hidden on the far side of the studio, in the typical 1960s apartment closets with folding doors, is the bulk of Peter Flinsch's work, consisting of many thousand drawings and paintings on paper. In preparing this book, I was only able to review approximately one-fifth of his materials. Hundreds, maybe thousands more, have made their way into collections around the world.

Early explorers of representations of homosexual erotica in Western art, like Raymond de Becker (1964) and Cécile Beurdeley (1977), compiled significant collections of images. More recent scholarly investigations by Emmanuel Cooper, Thomas Waugh, and other historians of gay visual culture have chronicled the legacy of erotic representations of men since the times of the ancient Greeks and Romans. Depictions of nude males was standard practice for the Greeks, who gloried in bodily perfection and did not care about which gender a man liked to penetrate so long as he was the "active" partner. Peter grew up in a world shaped by the Renaissance revival of these forms, as well as the Enlightenment's fascination with Classical art, which included a lot of nude statues, during the eighteenth century. But the predominance of the censoring fig leaf was already established by the nineteenth century, and it would be the task of the twentieth century to break the false modesty of bodily representations of the human male.

Peter was an active participant in the extensive international gay social and artistic networks which carried out a revolution in erotic male imagery in the 1960s and 70s and thereafter. As a boy in Leipzig, privileged to grow up in a household where art was taken seriously, he was exposed to the broadest range of styles from the old masters to the work of the Expressionist and New Objectivist movements before and after World War I. Reluctant to speak too much about the genesis of his style, Peter acknowledges Expressionists Egon Schiele, Emil Nolde, and George Grosz as artists to whom he felt close. His proximity to Schiele shows particularly in the awkward but expressively posed bodies of men in saunas, or cruising in the reeds. Unlike Schiele, however, who depicted women's genitals in meticulous detail but left everything rather

Flinsch as featured in the German magazine, *Him*, 1975. Photographed by Marcel Fugère.

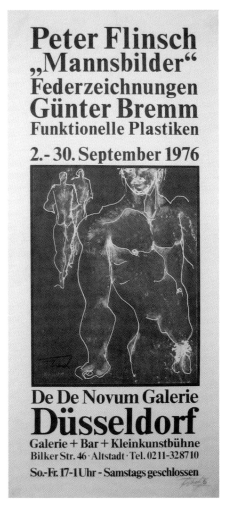

Invitation to an exhibition at the De De Novum Gallery, Düsseldorf, 1976.

indistinct when drawing penises, Peter has no such qualms. His men are expressive, more often than not, of an overt male horniness that few well-known artists before the 1950s dared to set down on paper.

The radical art movements of the early twentieth century in Germany, Austria, and France, with their new visual language mainly attuned to the bodies of women, opened up a cultural space for the understanding of the modern body as an object unto itself, an object of the gaze, and an object of desire. Meanwhile, in the United States in the 1930s, artists like Charles Demuth and Paul Cadmus were representing male eroticism with a new frankness, though their more explicit works may not have been widely shown. Such pioneers and precursors helped to pave the way for the emergence of a new category, "gay art," on the heels of the establishment of a socially cohesive "gay community."[20] While gay identity is a symbolic form, its manifestations on the social level are often closely linked to economics. With the politics of gay liberation came a whole new culture of gay art galleries with a self-aware clientele of well-heeled buyers for work that expressed aspects of their proud identity.

Although the stereotype of gay men as "artistic" is misleading, there are nonetheless many gay artists. For them and those who buy their work, there is a question to be resolved about "how gay" they ought to be. In many cases, especially for those working prior to or in the early years of gay liberation, they devoted only a small amount of their output to gay themes, given that there was no significant market for it until the 1970s because of the fear associated with being identified as gay. As confidence grew, however, cultural producers played an important role in promoting the gay collectivity's sense of itself as a community; a group sharing certain kinds of knowledge with social networks called into being an audience, a market, and a nascent critical literature on gay artwork.

The work of creative artists who were themselves gay and produced unique work that grew out of their experience as gay men was naturally more expensive to purchase than mass-market images, or even bodybuilding and physique photographs. Some of these artists were professional while others simply produced work for their own pleasure.

20 See surveys by Weinberg (2005) and Leddick (2110). The latter in-
cludes two works by Flinsch (pp. 122-23).

"Artisanal gay art" is a term offered by Thomas Waugh in connection with the production of pornography, but is equally apt in discussing artwork, as Waugh's himself makes clear. The category of "artisanal" denotes productions created without major capital investment, made by ordinary folks expressing their own authentic grassroots desires.

How far back such artistic currents go is debatable. Montreal's gay scene can trace its roots back to the mid-nineteenth century. A set of news items from 1869, in which men were arrested for crimes that would now be termed homosexual, provide precious clues to the existence of meeting places for men, both indoor and in public space, such as the promenade ground behind City Hall.[21] An item from 1886 refers to the same place as the haunt of fashionable young men speaking to each other in dulcet tones.[22] Strangely, the story refers to them as "dudes," a foreshadowing of the late-millennium vogue for this word. By 1930, the earliest period for which I was able to find men to interview on Montreal's gay history, the city boasted a vigorous gay social and cultural life (though not explicitly named as such, of course). Some of the men I interviewed had collected artworks with gay themes, including a wonderful shirtless rider on a rearing horse done in Plaster of Paris relief on a plaque. Such stirrings of "artisanal" approaches to "gay art" heralded the shift in mentality that emerged in the burgeoning gay community society in the 1960s.

These same men had almost all visited New York or Provincetown by 1970. Some were well aware of new political currents among gay men in the US, long before the advent of gay liberation in 1969 with the symbolically charged Stonewall Riots in New York. They were reading the new gay fiction of Gore Vidal and other writers, and looking at physique photos and the type of physique art distributed in the form of photographs. At least one Montreal collector (who donated the material to the Archives gaies du Québec) had bought copies of books of photography (1954) and drawings (1960) published in Switzerland by Der Kreis. Early in the postwar period, these handsome volumes established to all who saw them the scope and quality of what was unmistakably, using the phrase that only later became appropriate, as gay art.

21 For a full account of these sources, see Higgins (1999).

22 "L'association nocturne," La Presse (June 30, 1886): 4.

Flinsch in Vancouver, 1975, photographed by
Uwe Meyer.

Gay Art Comes Out

For both Peter and the scene as a whole, the status of gay art and artists
has improved tremendously since the 1970s. Politicians and the gen-
eral public slowly began to accept the gay community on its own terms
(albeit with marked exceptions). New businesses courted the newly
perceived market of affluent young men (and some women) with no
dependents and excessive disposable income. Part of that income went
into purchasing art that expressed gay identity. Thomas Waugh's books
Hard to Imagine (1996), *Out/Lines* (2002), and *Lust Unearthed* (2004) reflect
some of the ways gay artists responded to the market. One name, that of
George Quaintance, gained early recognition.[23] Like other gay artists,
his work circulated in photographic copies, distributed through the
same networks that distributed a much higher volume of physique photos
and illicit erotic photos of men. Quaintance focused on a small range
of iconic figures, from the bullfighter (made plausible by his residence
in New Mexico) to the cowboy, the ultimate icon of masculinity in the
1950s. After Quaintance's early death, the leader of gay artistic pro-
duction is unquestionably Tom of Finland.[24] From early beginnings in
Helsinki, he developed a fascination with uniforms and men's bod-
ies into one of the most widely recognized symbols of gay imagery. His
homoerotic work has a distinctive obsessiveness that makes it instantly
identifiable.

Peter Flinsch, on the other hand, was never content to settle down
to one restricted set of iconic images, to one narrow visual vocabulary
or technique. He has a very distinctive range of styles, as the work
presented here makes clear. Some of these remind the viewer of
Cocteau's line art or that of other artists featured in Waugh's *Out/Lines*.
A watercolour and ink drawing in my own collection shows two naked
men in a dance studio who seem to be rehearsing with two long poles
with onlookers in the background, one of whom has prominent genitals
highlighted by a splash of red. This exemplifies the complexity and
subtlety of Flinsch's approach and underscores his commitment to a
broad, insightful vision of men and masculinity.

Having paid a heavy price for a careless kiss at a Christmas party
in 1942, Peter Flinsch was forthright and determined about what he

23 Janssen (2003).

24 Hooven (1993); Arell and Mustola (2006).

wanted to paint, draw, or sculpt. He welcomed and participated in the new impatience with which gay men regarded their outcast taboo status. With a secure income from his day job, his art was not dependent on sales in a market not yet ready for male nudes in erotic situations. By the time of his first big New York show in 1972, Peter had had time to slowly extend his range of styles and techniques as he refined his eye for the themes that interested him. He had the time and the energy, the training and the experience of the world, to pursue his creative muse that artists who depended on sales could not.

In October 1977, on a Friday night around eleven, 146 men were arrested in a raid on Truxx, one of the most popular gay bars in downtown Montreal. The massive response of the emerging gay community to this event transformed gay life in Quebec and set the stage for legal changes for gays and lesbians across Canada. For several years, there had been muted responses to renewed police intervention in Montreal's thriving gay bars. A wave of arrests during raids on saunas and bars preceded the Montreal Olympics in 1976. After the 1977 raid sparked a mass demonstration with broad support of the public, Quebec's government moved to include sexual orientation in its provincial human rights legislation (the first province in Canada to do so). The new militancy also led to the first public exhibition of art labeled as "gay": "Imagerie homosexuelle," which was organized by Serge Fisette in 1978. The work by a group of local gay artists signalled the new militancy to the city's art world. Though Peter was not part of this show, he had been militant in his own way for a couple of decades at least by the time the 1978 show marked a clear shift to openly gay artistic production by members of the younger generation.

Peter's oeuvre included many styles of masculine icons. He pictured men who, with some features distorted slightly, become representative types in a visual language clearly readable by other gay men. With the passage of time, this language, thanks to Calvin Klein and other pioneers of male representation in advertising and art after 1980, has become commonplace, unexceptional. When the revolutionary, the absolute taboo becomes ordinary, those who have not known how it was before are often unable to see what has really changed, and so may forget the vision and the courage of those whose efforts helped effect those changes.

Poster for Montreal's first group show of "gayart," 1978. Courtesy of the Archives gaies du Québec.

Peter was not alone in striving to document gay desire in art, but he had the advantage of training, drive, and talent that set him apart from others. His huge body of work will be valued for a long time for its frankness and humour. It documents a changing world, one where variations on gay identities exist, from which a gay aesthetic emerges, well away from the Western cities where they first appeared. As a result of his travels from Tunisia to South Africa in the 1980s and 90s, Peter's work also delves into the relationship between tourist and local, between older visitor and younger local eager for contact with the larger world, sometimes with a sharp look at the commercialism this can involve. Ultimately, however, Peter's portraits reflect the tensions, the camaraderie, and the complicity that exists between subject and artist.

Public Artist

In the 1990s, a university faculty member and friend of Peter's put together a proposal for an exhibition of his work at a Montreal university gallery. The package was hastily returned with the brief comment, "No thank you." scrawled on the cover. The faculty friend read the message as saying "This is not art," or even "No hunks please, we're radical." Really? How radical does art need to be that gets artists sent to jail, ruins lives, and sometimes even ends them when the strain of being outcasts becomes too much to bear? Luckily this was just one disappointment in an otherwise triumphant series of exhibitions of Peter's work beginning in the early 1970s. Peter began his official career as a "gay artist" with a 1972 show at the institution that would grow into the Leslie/Lohman Gay Art Foundation in New York. (In 2006, the foundation organized a retrospective on Peter's long career in their new gallery premises in Soho, and presented him with a lifetime achievement award to mark the occasion.) Some of these shows were notable occasions, like the opening of his show in Hamburg in 1983. The opening at midnight was by invitation only, and it was announced that the artist would be making nude sketches of guests who wanted to pose. Long before midnight, the line-up for admission stretched around a city block; among those who posed were a countess with her lover, as well as a handsome naval officer. Quite the "happening," Peter recalls, and it was very widely reported in the local papers. Another memorable event was the celebration of his seventieth birthday by having three exhibitions in Montreal at the same

time. At the end of the millennium, he was honoured by a large exhibition at the Écomusée du Fier Monde in Montreal, and since then has had regular smaller shows in his adopted home town.

An interesting inclusion in some of the publicity materials for exhibitions in the 1970s is a list of collections in which Peter's work could be found, a kind of who's who of gay art collectors at the time, from Vancouver to Rome. Peter has been selling his work for a long time, as well as donating it to individuals and institutions (such as the Archives gaies du Québec); he has also generously given his art for auctions to benefit AIDS charities. Another major donation of drawings is now in the collections of the Schwules Museum in Berlin.[25] Peter's work always finds buyers, either through his dealers or on the Internet (*peterflinsch.com*). He has been well represented locally and internationally through participation at events like the annual Festival des Arts, held in early summer in the Gay Village.

Peter's work has also attracted much attention from the media. His scrapbooks bulge with clippings from German newspapers from the mid-1970s and various gay magazine articles, always well illustrated with images of his work. He received early and regular attention from *After Dark*, a well-known gay cultural magazine published in New York. His art has also had a lot of exposure through inclusion of pieces in presentations by noted gay art commentators like David Leddick and Thomas Waugh, and in 1998, Volker Janssen, a gay publisher in Berlin, issued a book of his line drawings under the title *Der Mann in der Kunst: Peter Flinsch*.[26]

This book, however, presents Peter's work for the benefit of a wider audience. We have purposely narrowed his wide range of material to those concerned with the representation of the male form, masculinity, and the erotics of man on man, based on the sampling I was able to do of his enormous output.

The images selected emphasize three major aspects of Peter's vision of the world on which his gaze has remained firmly fixed since his youth. First and foremost, Flinsch summons us to think about men, about how men inhabit their bodies and desire other men's bodies; in workplaces, on the street, at the bar, in the gym and locker room,

25 Two photos of Flinsch appear in Sternweiler (2004).

26 Berlin: Janssen Verlag.

Flinsch in his studio, 2006, photographed by
Ross Higgins.

or in bed. He wants us to think too about the man within the body;
his portraits of many different kinds of men deftly reveal masculine
interiority in a few simple lines. Second, he takes us on a guided tour
of the gay world à la Flinsch, mainly in Montreal but also in Germany
and places seen in his travels, especially in Africa. Depicting Montreal's
bar scene brings out Peter's most acerbic comments on the vanity and
pretension of gay life in the snake pit of the cruising bar. In their own
way, his archetypal exaggerations of gay Montreal are just as over the
top as those of Tom of Finland, but more focused on the ironic side of
gay culture than on bulging baskets. The baskets are there, but Flinsch
is more interested in who is saying what to whom (most picture titles
are dialogue, or words loom over the heads in the image). He likes to
make visual jokes about overweight men in leather and cute-but-dumb
disco bunnies dolled up for a night out. He sees glances exchanged and
deflected in the merciless pursuit of the hook-up where the same old
faces vie for the attention of the good-looking tourists and newcomers.
Third, Flinsch likes to look at all fit bodies, erotic bodies, athletic
bodies, dancing and competing bodies, whether male or female. He
examines conflicts and complicities between men and women, but from
a distinctly gay point of view. In Peter's threesomes, the woman is often
quite the outsider. But this is not an expression of hostility to women,
just a little gay rivalry.

In addition to these three major themes, the selection that follows
includes several images of what I have previously called Peter Flinsch's
"Mysteries"—exotic supernatural images of birds flying, the moon, and
strange objects of no fixed nature. This series represents more abstract
figures in allegorical representations, such as Plate 92, *Origin of the Species*,
or the strange ceremony in Plate 98, *Moonstruck/Lunaire*. Even in these
drawings, the erotic element is often present.

Self-portraits are few and far between in the work of Peter Flinsch.
Throughout his remarkable life, Peter has been looking out at the
world, observing all the nice ladies and elegant gentlemen. Later, the
gentlemen became elegant not for their spiffy clothes, but for how they
looked when they undressed. Surviving childhood and youth in Nazi
Germany, his arrest in 1942 for kissing another man, prison, and
front-line service for the rest of the war meant, most significantly for
the work presented in this collection, that as a result of his experience

he became totally fearless in pursuit of his chosen vehicle of self-expression. He devoted all his spare energies to pursuing his artistic exploration of the male form.

With many exhibitions to his credit, Peter has long been a participant in the international gay art scene. Who could have foretold in the dark days of the war that such a man would one day set Hamburg on its ear, as Flinsch did in the spring of 1983? Early in his life, Peter learned a crucial lesson in oppression and courage, and conducted his life and directed his artistic energy to the full expression of his love and admiration for men at a time when society showed little sympathy for any depictions of the male form. His work merits wider exposure than can be achieved in gallery shows alone. This book should help to bring him before a wider public, and it is my hope that the publication will encourage more in-depth explorations of his output and evaluations of his place among the pioneers of gay art in the twentieth and twenty-first centuries.

"I've seen many changes in my life, from incarceration to liberation. I hope I will see the day when the gay movement becomes just part of the fabric of society. That would be wonderful, but of course it hasn't happened yet. The very fact that you are exploring my work, though, is another step to make gay culture an accepted part of society." Let us hope that future generations will appreciate Peter Flinsch's courage and determination in pursuit of his goal, and most of all, his wonderful images.

REFERENCES

Arell, Berndt, and Kati Mustola. *Tom of Finland: Ennennäkemätöntä—Unforeseen.* Helsinki: Like, 2006.

Becker, Raymond de. *L'érotisme d'en face.* Paris: Jean-Jacques Pauvert, 1964.

Beurdeley, Cécile. *Beau Petit Ami.* Fribourg: Office du livre, 1977.

Cooper, Emmanuel. *The Sexual Perspective: Homosexuality and Art in the Last 100 Years in the West.* London and New York: Routledge & Kegan Paul, 1986.

Elger, Dietmar. *Expressionism: A Revolution in German Art.* Köln: Taschen, 2002.

Falkon, Felix Lance, and Thomas Waugh. *Gay Art: A Historic Collection.* Vancouver: Arsenal Pulp Press, 2006.

Flinsch, Peter. *Der Mann in der Kunst 4 Peter Flinsch.* Berlin: Janssen Verlag, 1998.

———. The Art of Peter Flinsch (website with numerous galleries of the artist's work, biography, list of exhibitions, and order forms) http://www.peterflinsch.com (accessed July 2, 2008).

Higgins, Ross. "Sense of Belonging: Pre-liberation Space, Symbolics and Leadership in Gay Montreal." PhD diss., McGill University, Montreal, 1997.

———. "Des lieux d'appartenance: les bars gais des années 1950." *Sortir de l'ombre: histoires des communautés lesbienne et gaie de Montréal.* Edited by Irène Demczuk and Frank W. Remiggi. Montreal: vlb éditeur, 1998: 103-128.

———. *De la clandestinité à l'affirmation: pour une histoire de la communauté gaie Montréalaise.* Montreal: Comeau et Nadeau (Lux Editeur), 1999.

Hooven, F. Valentine III. *Tom of Finland: His Life and Times.* New York: St. Martin's Press, 1993.

Janssen, Volker. *The Art of George Quaintance.* Revised edition. Berlin: Janssen Verlag, 2003.

Kallir, Jane. *Egon Schiele: Life and Work.* Condensed edition. New York: Harry N. Abrams, 2003.

Kinsey, Alfred C., Wardell B. Pomeroy, and Clyde E. Martin. *Sexual Behavior in the Human Male.* Philadelphia/London: W.B. Saunders Company, 1948.

Leddick, David. *Male Nude Now: New Visions for the 21st Century.* New York: Universe Publishing, 2001.

Lewis, Philip, and Jean-Francois Monette. *Eye on the Guy: Alan B. Stone and the Age of Beefcake.* Video. Produced by Lisa Cochrane. Writer and archival consultant: Ross Higgins. Amérimage-Spectra, 2006.

Der Mann in der Photographie. Zurich: Der Kreis, 1954.

Der Mann in der Zeichnung. Zurich: Der Kreis, 1960.

Rux, Conny. *Ich schlage mich durch!.* Berlin: Arani-Verlag, 1950.

Shirer, William L. *The Rise and Fall of the Third Reich: A History of Nazi Germany.* New York: Simon & Schuster, 1960.

Steakley, James D. *The Homosexual Emancipation Movement in Germany.* New York: Arno Press, 1975.

Sternweiler, Andreas. *Liebe, Forschung, Lehre. der Kunsthistoriker Christian Adolf Isermeyer.* Berlin: Schwules Museum, 1998.

———. *Self-confidence and Persistence: Two Hundred Years of History.* Berlin: Schwules Museum, 2004.

Turnbaugh, Douglas Blair. "Imageman Peter Flinsch," *Journal of the Leslie/Lohman Gay Art Foundation,* no. 20 (Summer 2006): 19-22.

Waugh, Thomas. "Gay Male Visual Culture in North America During the Fifties: Emerging from the Underground." *Parallelogramme* I, no. 2 (Autumn 1986): 63-67.

———. *Hard to Imagine: Gay Male Eroticism in Photography and Film From Their Beginnings to Stonewall.* New York: Columbia University Press, 1996.

———. "Des Adonis en quête d'immortalité: la photographie homoérotique." In *Sortir de l'ombre: histoires des communautés lesbienne et gaie de Montréal.* Edited by Irène Demczuk and Frank W. Remiggi. Montreal: vlb éditeur, 1998: 53-79.

———. *Out/Lines: Underground Gay Graphics from Before Stonewall.* Vancouver: Arsenal Pulp Press, 2002.

———. *Lust Unearthed: Vintage Gay Graphics from the DuBek Collection.* Vancouver: Arsenal Pulp Press, 2004.

Weinberg, Jonathan. *Speaking for Vice: Homosexuality in the Art of Charles Demuth, Marsden Hartley, and the First American Avant-Garde.* New Haven/London: Yale University Press, 1993.

———. *Male Desire: The Homoerotic in American Art.* New York: Harry N. Abrams, 2005.

Weyrauch, Wolfgang. *Auf der bewegten Erde.* Berlin: F.A. Herbig Verlag, 1946.

Zwätz, Ingrid. Video. *Peter Flinsch.* 1986.

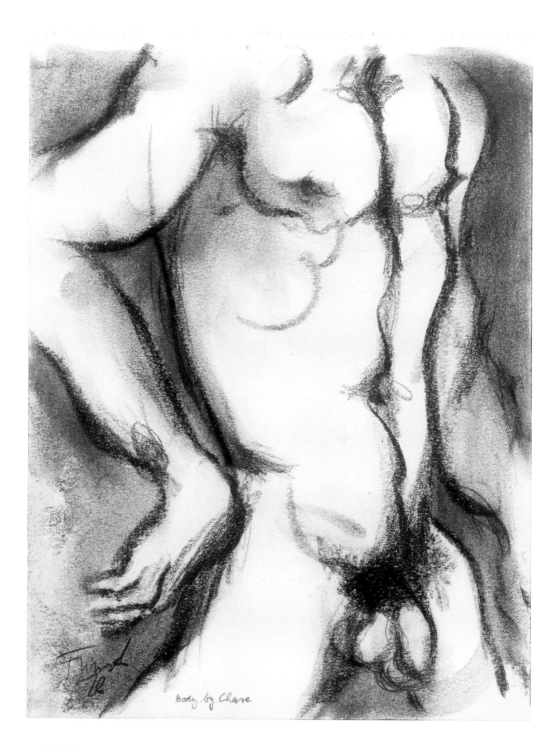

PLATE I
Body by Chase, 1976, pastel, 30 x 23 cm

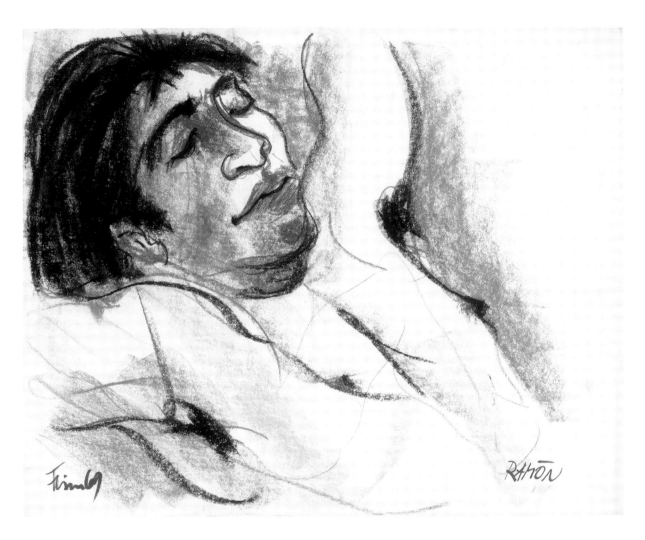

PLATE 2
Ramón, 1969, pastel, 61 x 49 cm

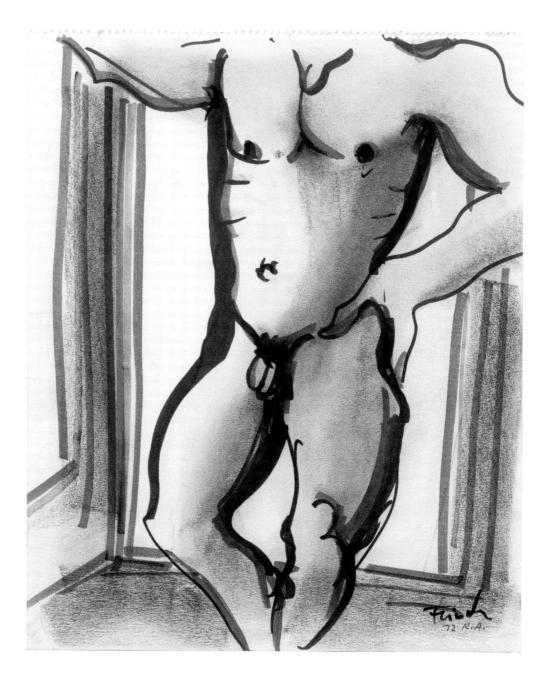

PLATE 3

R.A., 1972, marker and pastel, 43 x 35 cm

PLATE 4
Ben B., 1980, pen and black and white ink on grey paper, 23 x 30 cm

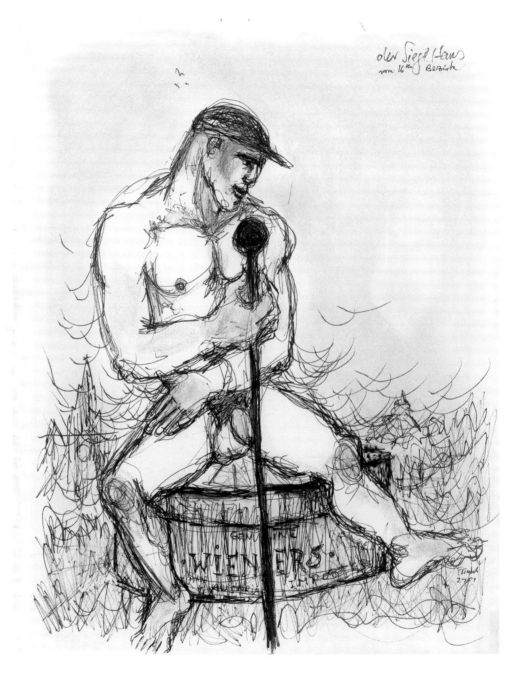

PLATE 5
Der Siegl Hans, 2001, micropen and watercolour, 36 x 28 cm

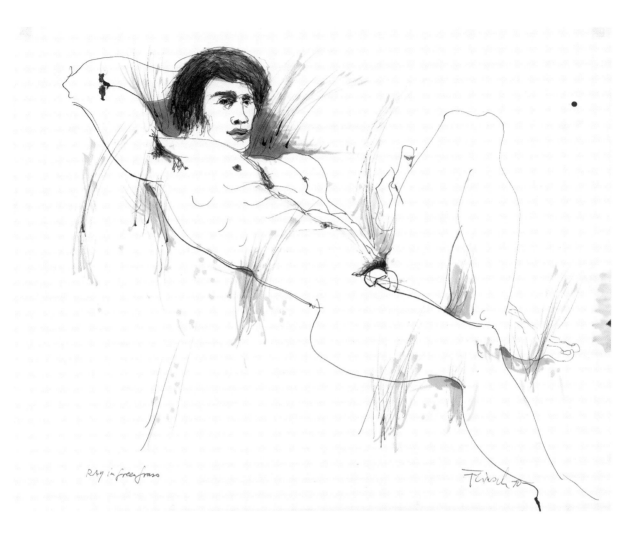

PLATE 6
Ray in Green Grass, 1970, pen and ink and watercolour, 46 x 61 cm

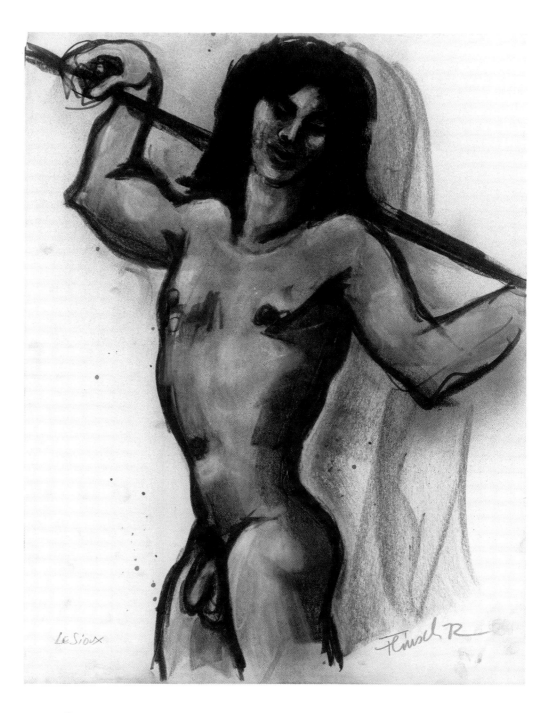

PLATE 7
Le Sioux, 1972, pastel, 61 x 46 cm

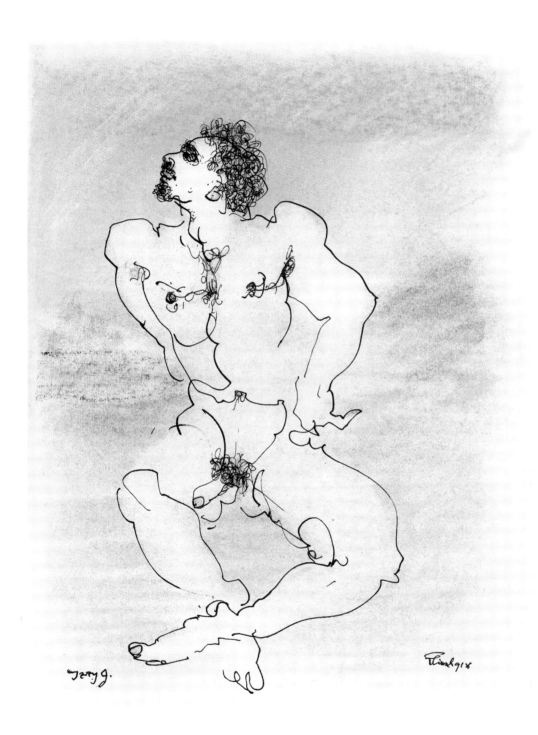

PLATE 8
Jerry G., 1991, pen and ink and pastel, 35 x 27 cm

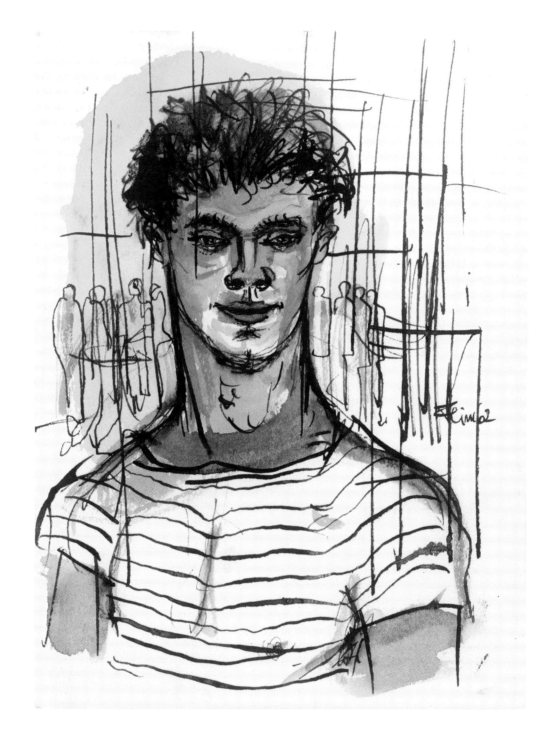

PLATE 9
André Burns in T-shirt, 1962, pen and ink and watercolour, 17 x 13 cm

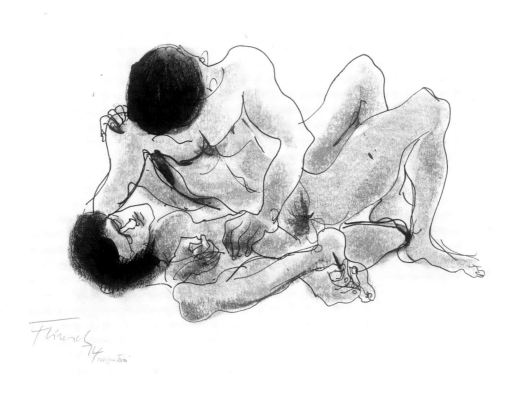

PLATE 10
Ralf & Gene Tsui, 1974, pen and ink and pastel, 46 x 61 cm

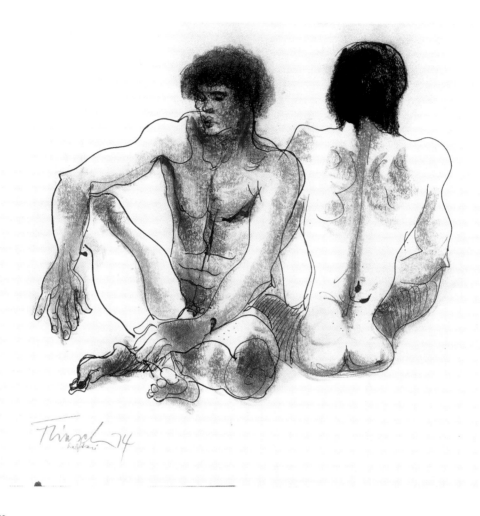

PLATE II
Ralf & Tsui (back to back), 1974, pen and ink and pastel, 46 x 61 cm

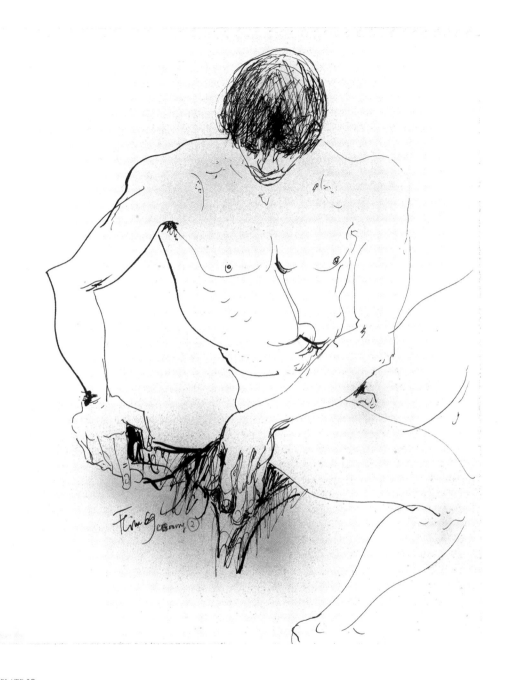

PLATE 12
Barry (2), 1969, pen and ink and colour spray, 43 x 35 cm

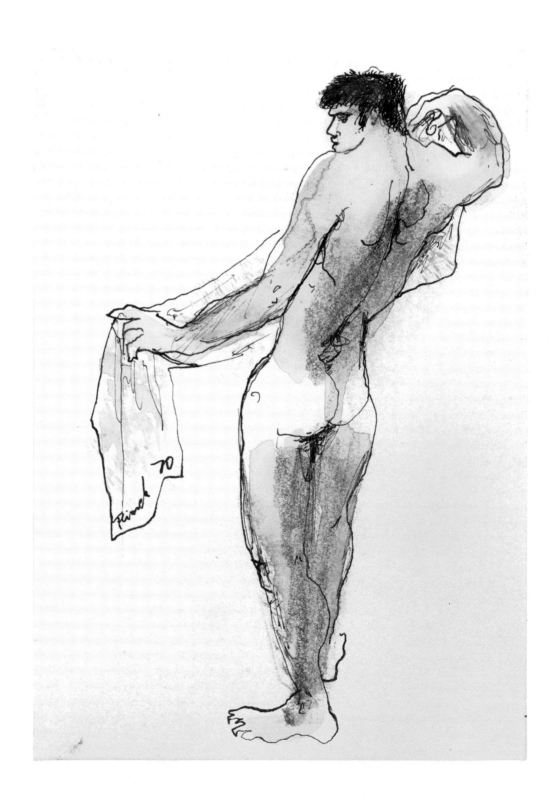

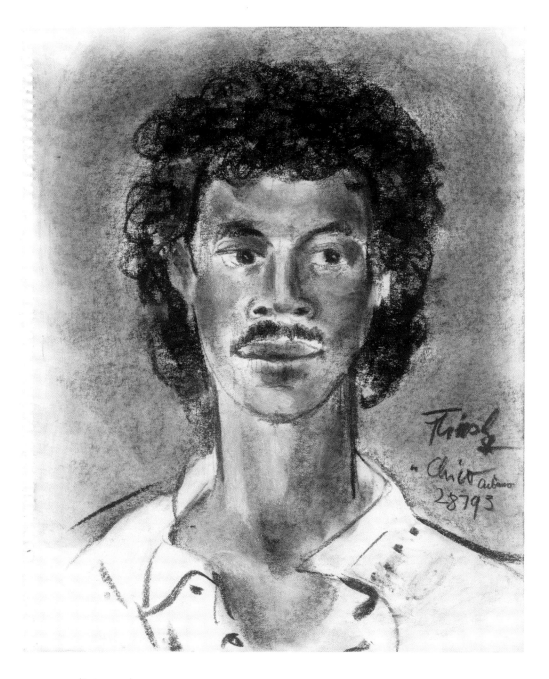

PLATE 13 (facing page)
Len, 1970, pen and ink and watercolour, 17 x 12 cm

PLATE 14 (above)
Chico Cubano, 1993, pastel, 43 x 35 cm

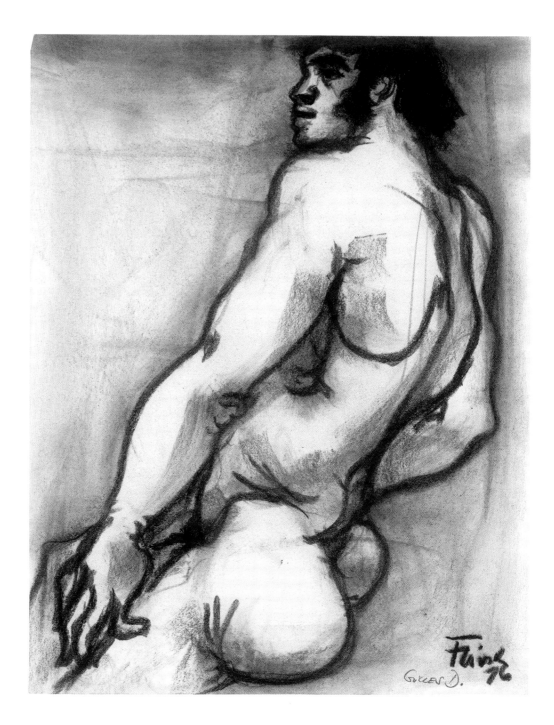

PLATE 15
Gilles D., 1976, pastel, 61 x 46 cm

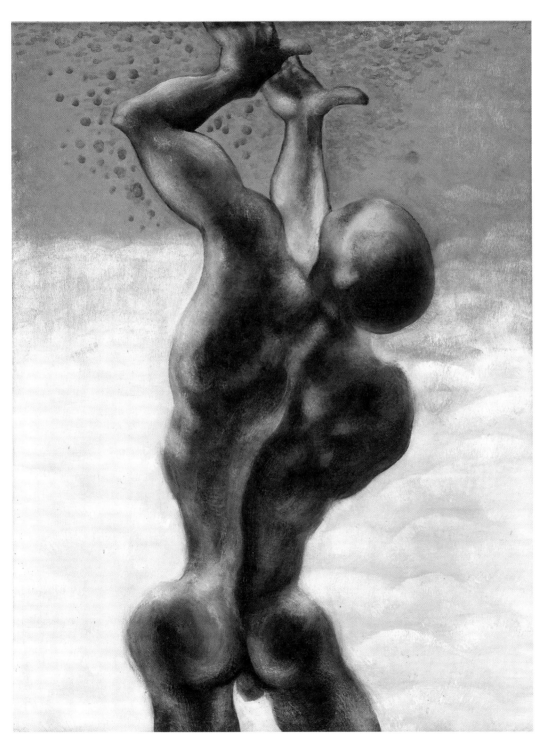

PLATE 16

Tanaka, the Japanese Dancer, 1980, oil on masonite, 117 x 91.5 cm

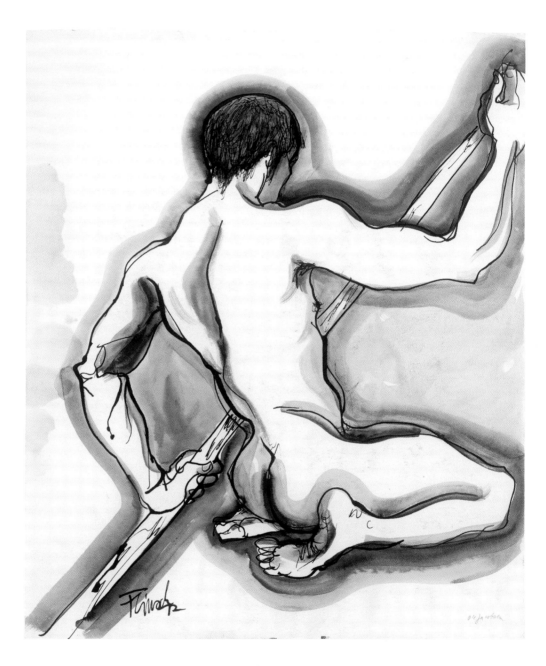

PLATE 17
Ole Jacobsen, 1972, pen and ink, washed, 43 x 36 cm

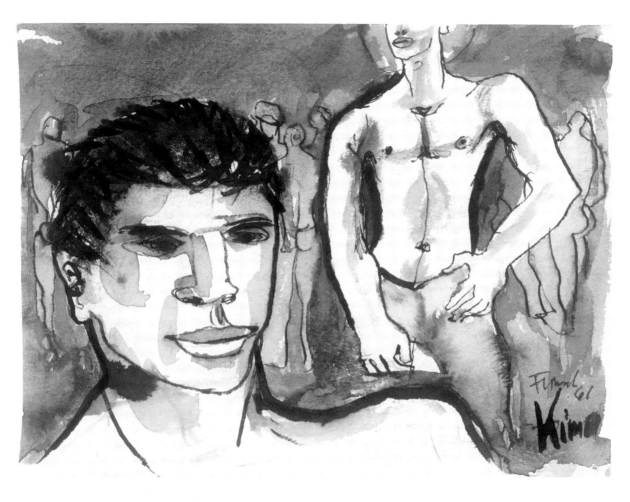

PLATE 18
Kim, 1961, pen and ink, washed, 12 x 17 cm

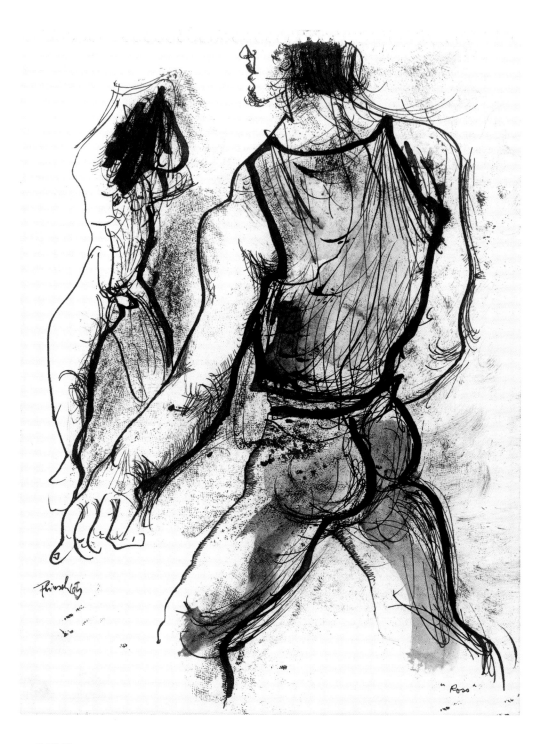

PLATE 19
Ross, 1965, pen and ink, washed, 30 x 23 cm

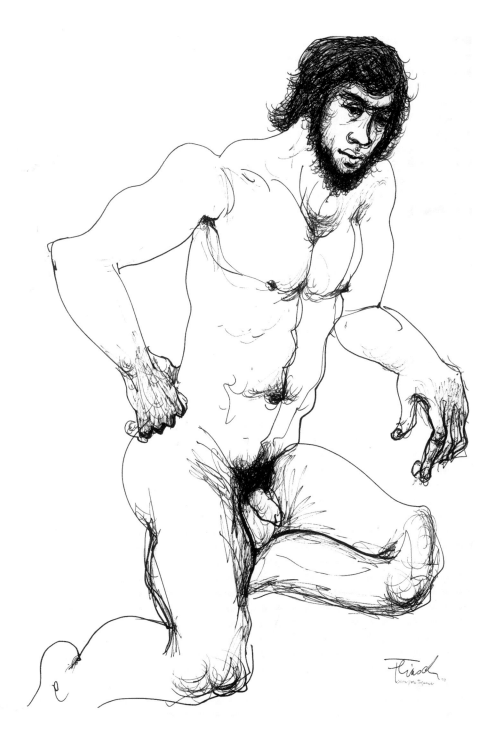

PLATE 20
Jean-Yves Trépanier, 1973, pen and ink, 61 x 46 cm

PLATE 21
Normand, 1975, pastel, 48 x 62 cm

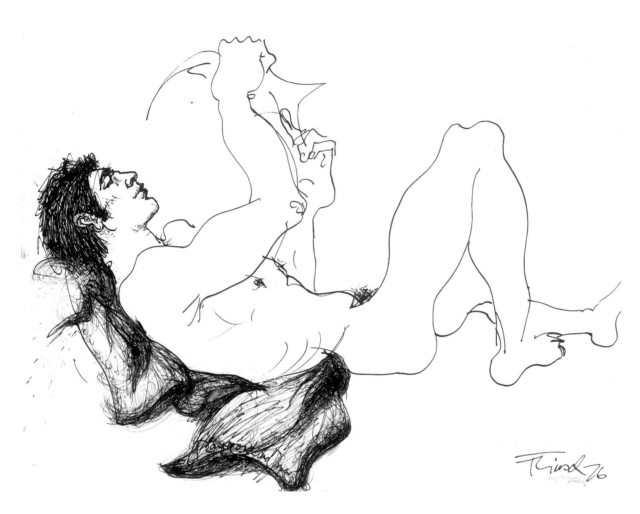

PLATE 22
Ray Artuso Reading, 1976, pen and ink, 61 x 46 cm

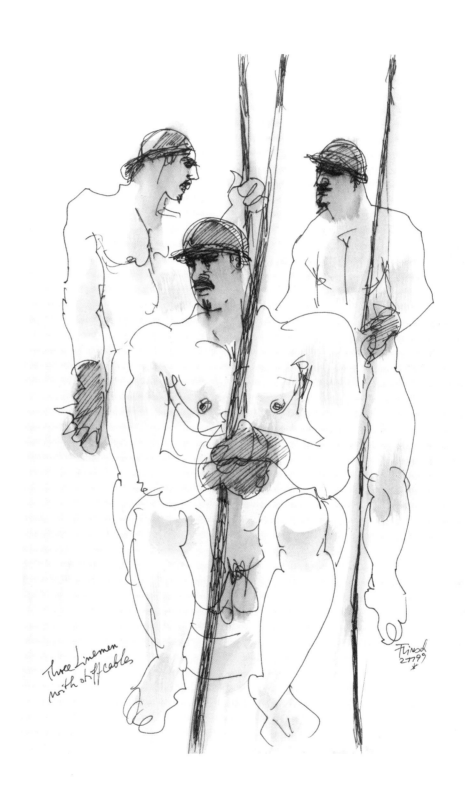

Three Linemen
with stiff cables

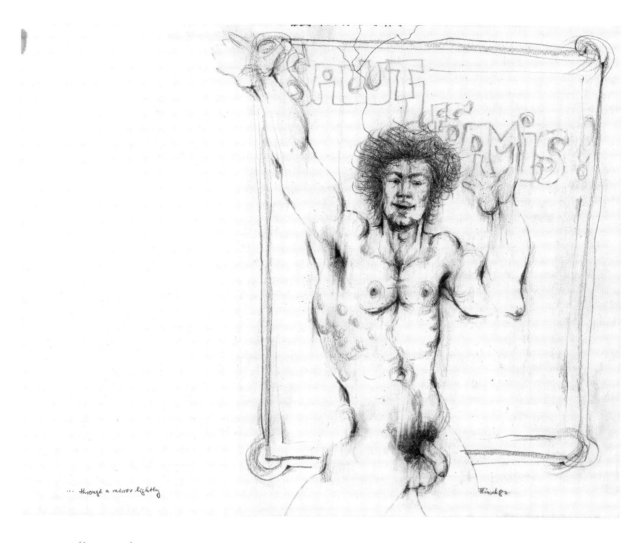

... through a mirror lightly

PLATE 23 (facing page)
Three Linemen with Stiff Cables, 1999, pen and ink, washed, 36 x 27 cm

PLATE 24 (above)
Through a Mirror Lightly, 1982, pencil, 27 x 35 cm

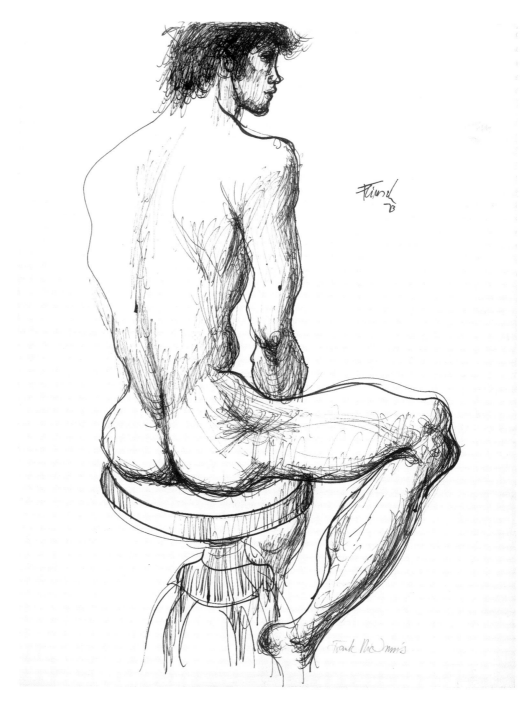

PLATE 25
Frank McInnis, 1973, pen and ink, 60 x 46 cm

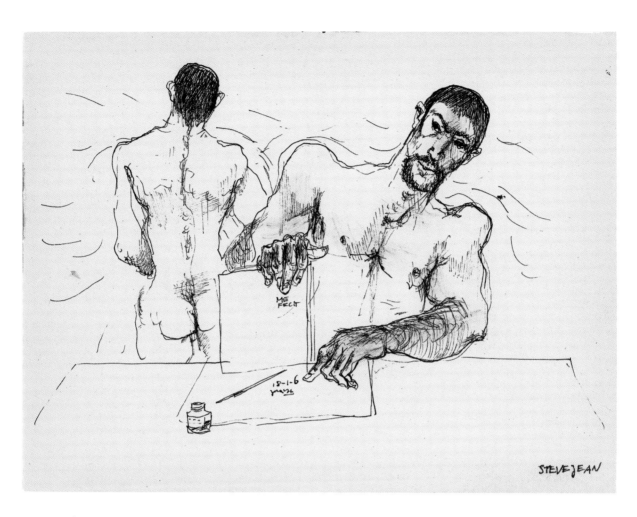

PLATE 26
Steve Jean, 1981, pen and ink on cream paper, 23 x 31

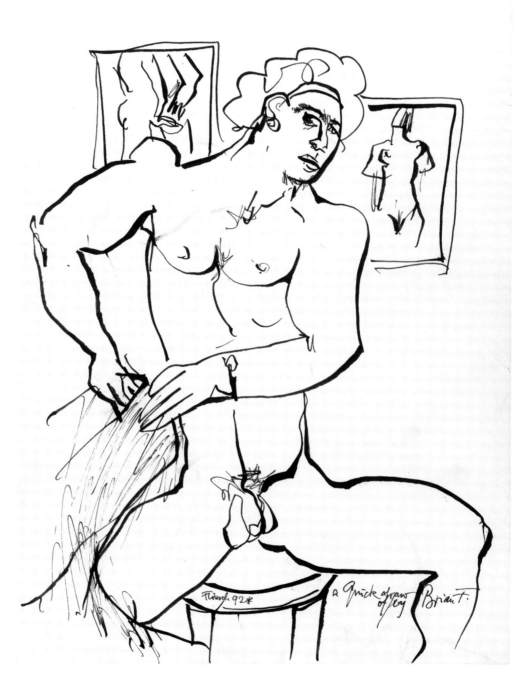

PLATE 27
A Quick Draw of Brian F., 1992, pen and ink, 35 x 27 cm

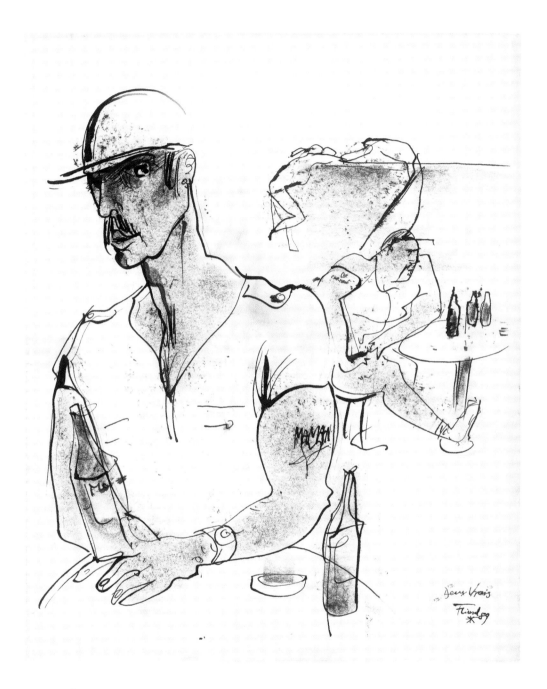

PLATE 28
Deux vrais, 1989, pen and ink and graphite, 43 x 35 cm

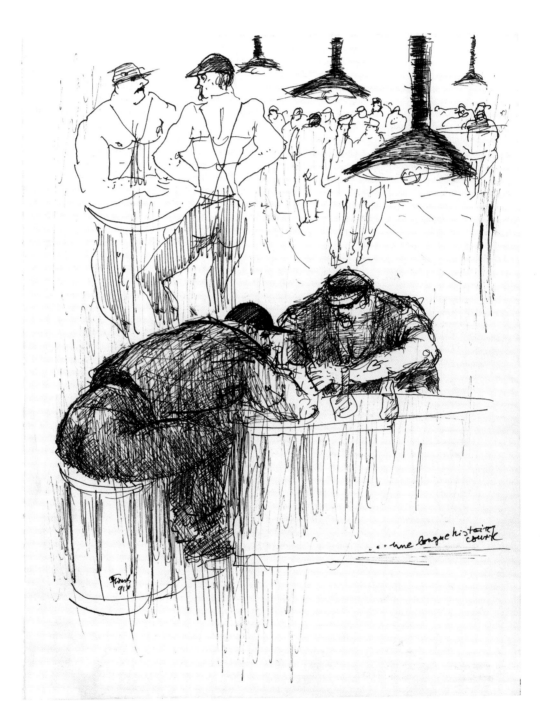

PLATE 29
Une longue histoire courte, 1991, micropen, 35 x 27 cm

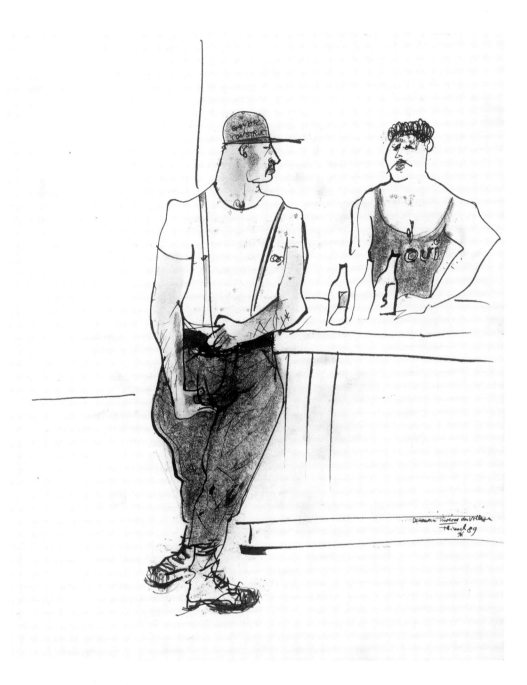

PLATE 30
Deux au Taverne du Village, 1989, pen and ink and graphite, 43 x 35 cm

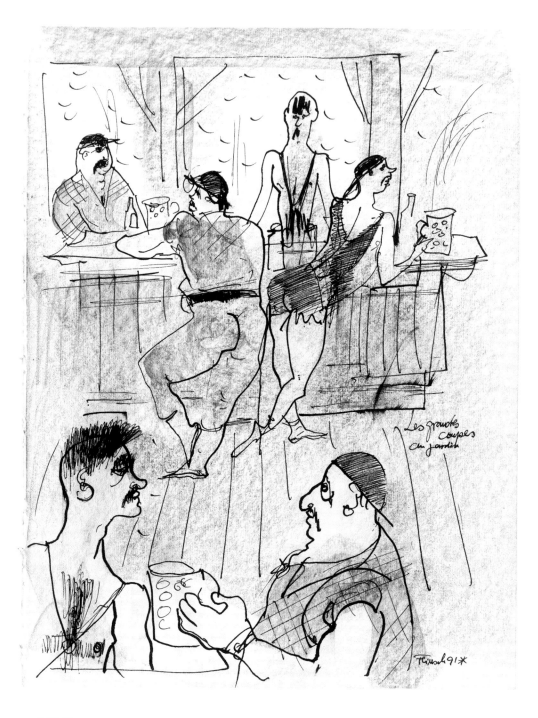

PLATE 31
Les grandes coupes au jardin, 1991, micropen and graphite, 35 x 27 cm

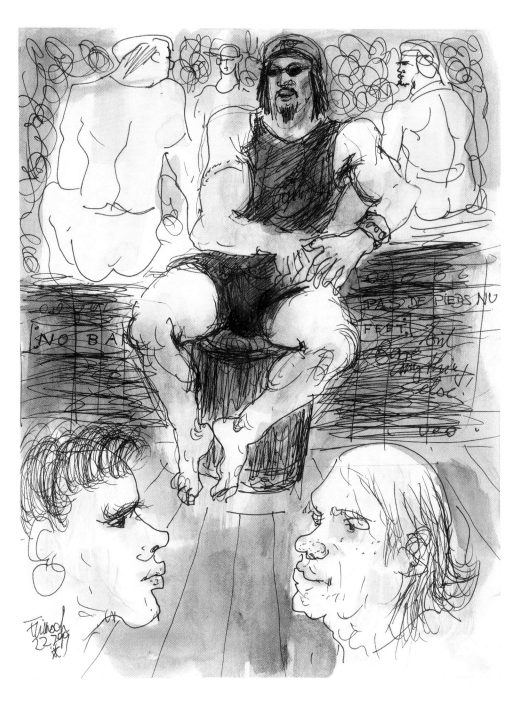

PLATE 32
No Bare Feet, 1999, micropen washed, 35 x 27 cm

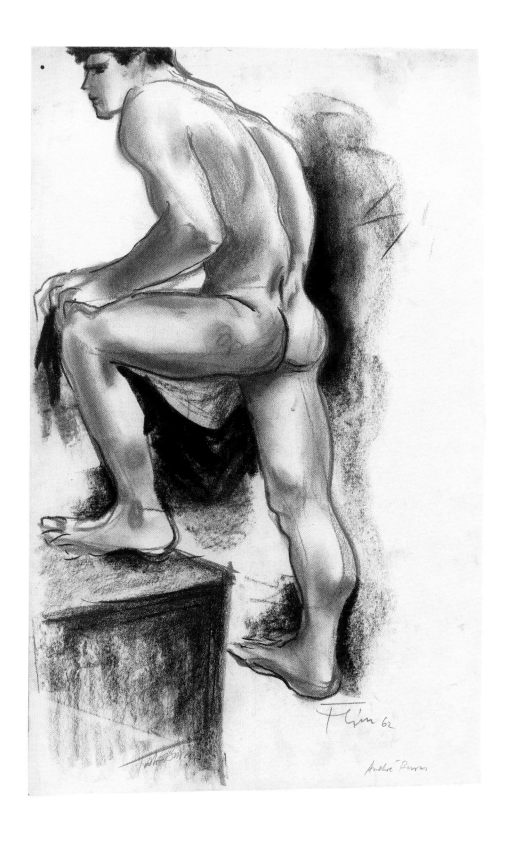

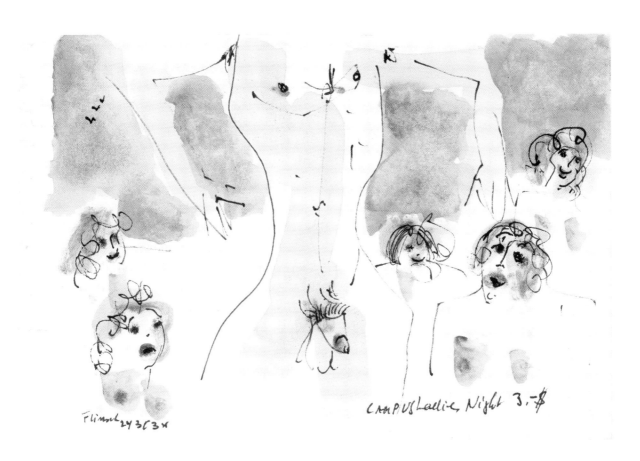

PLATE 33 (facing page)
André Burns, 1962, pastel, 50 x 31 cm

PLATE 34 (above)
Campus Ladies Night $3, 2003, micropen and watercolour, 10 x 14 cm

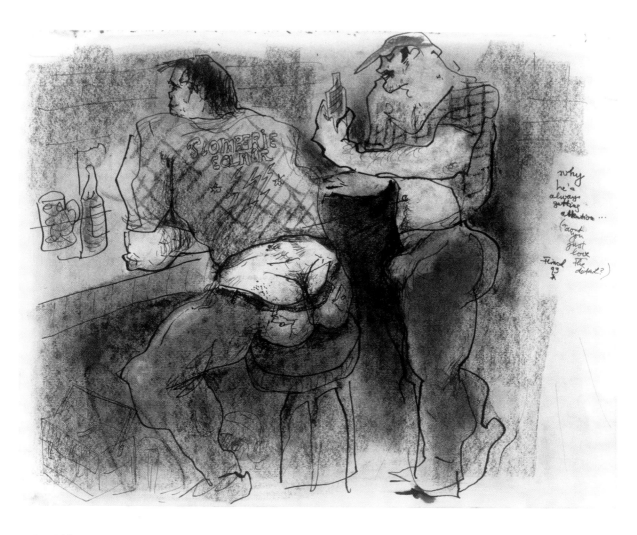

PLATE 35
Why Is He Always Getting Attention?, 1993, micropen and pastel, 27 x 35 cm

PLATE 36 (facing page)
Le bain juif (Colonial), 1970, pen and red ink and colour spray, 17 x 13 cm

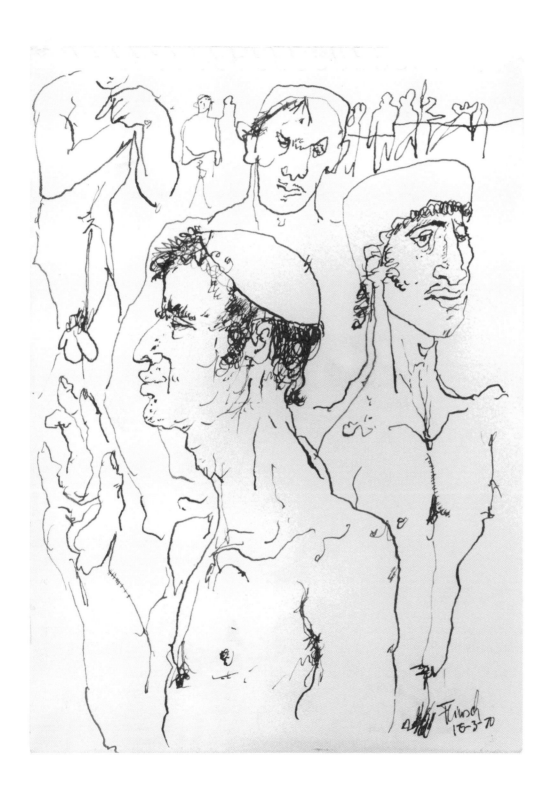

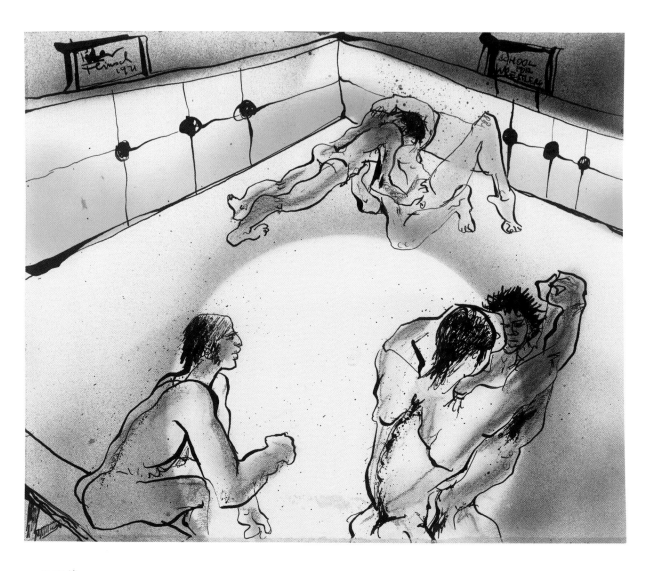

PLATE 37
School for Wrestlers, 1971, pen and ink and colour spray, 27 x 35 cm

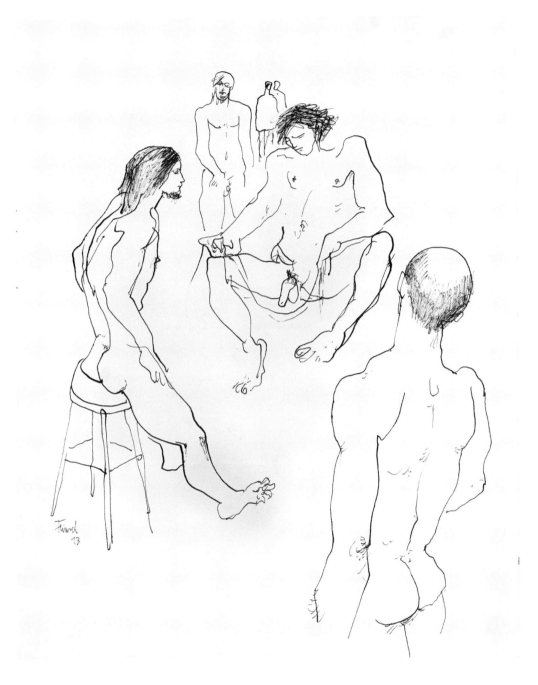

PLATE 38
Nach dem spiel (After the Game), 1973, pen and ink and colour spray, 35 x 28 cm

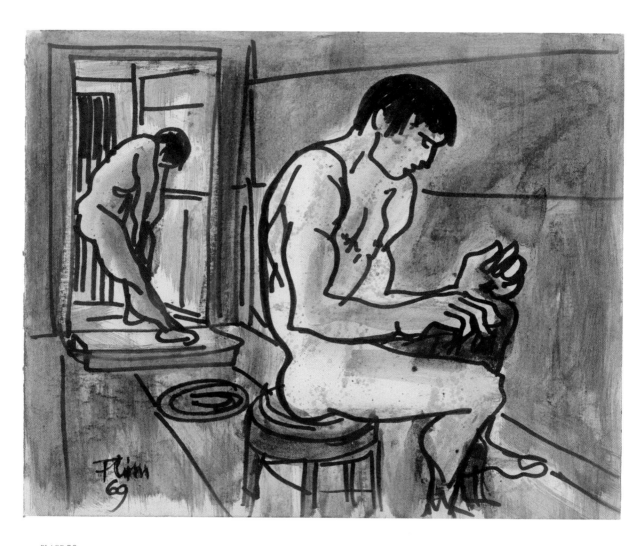

PLAGE 39
Drying Off, 1969, black marker and gouache on board, 48 x 61 cm

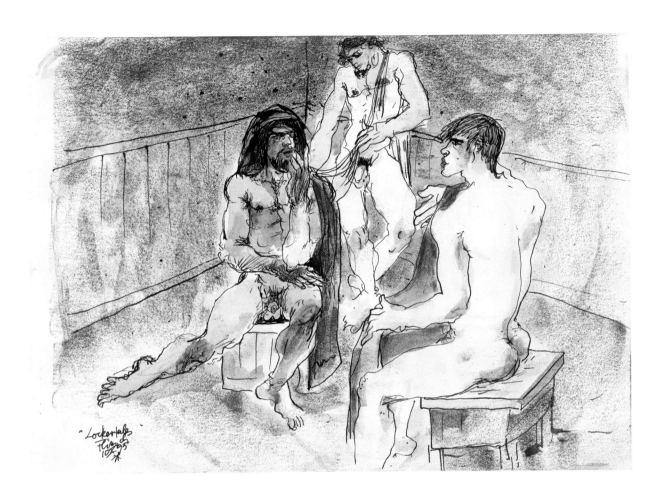

PLATE 40
Locker Tales, 1995, pen and ink and watercolour, 30 x 42 cm

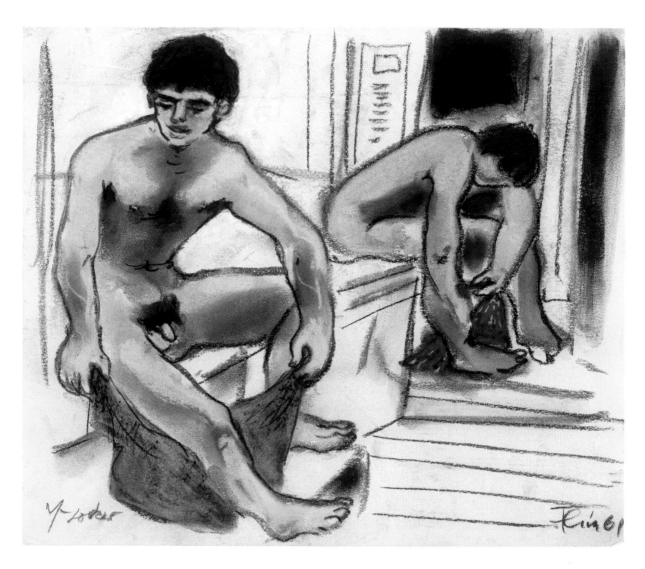

PLATE 41
Y Locker, 1961, pastel, 35 x 43 cm

PLATE 42 (facing page)
Napier, USA, Wrestler, 1975, marker and pastel, 42 x 35 cm

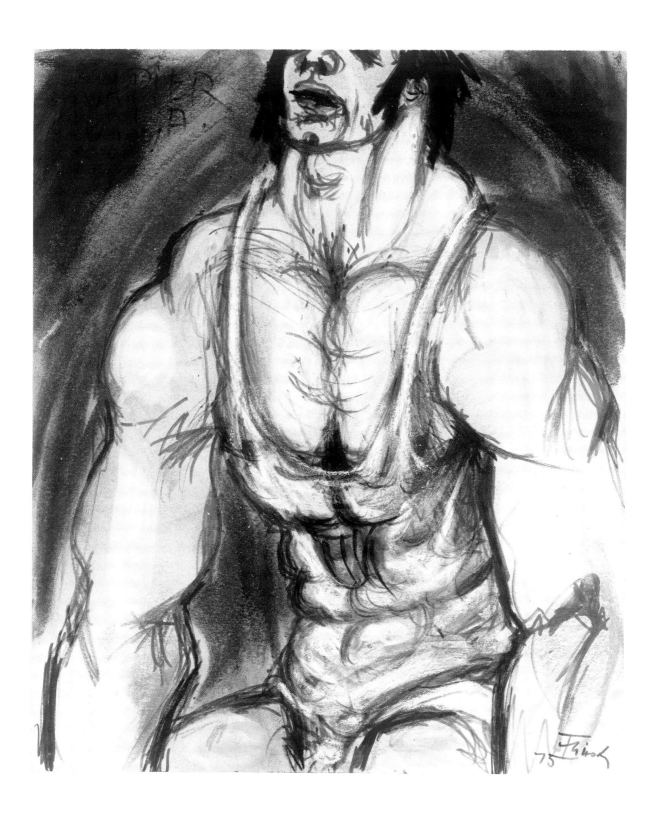

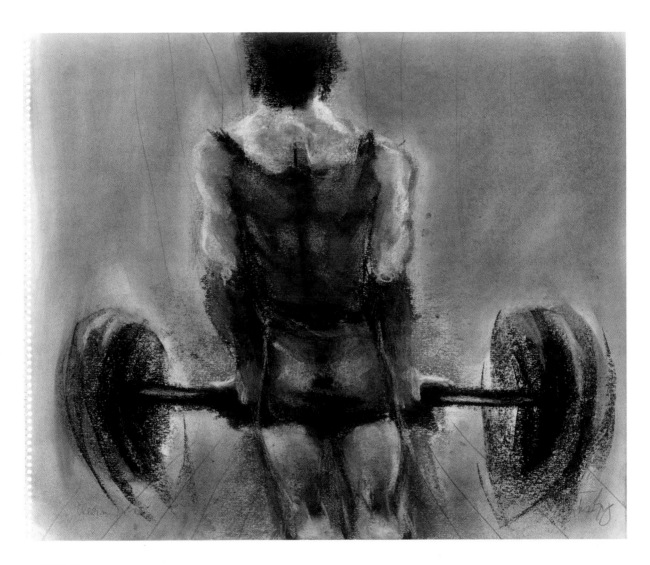

PLATE 43
Clean Press, 1978, pastel, 35 x 43 cm

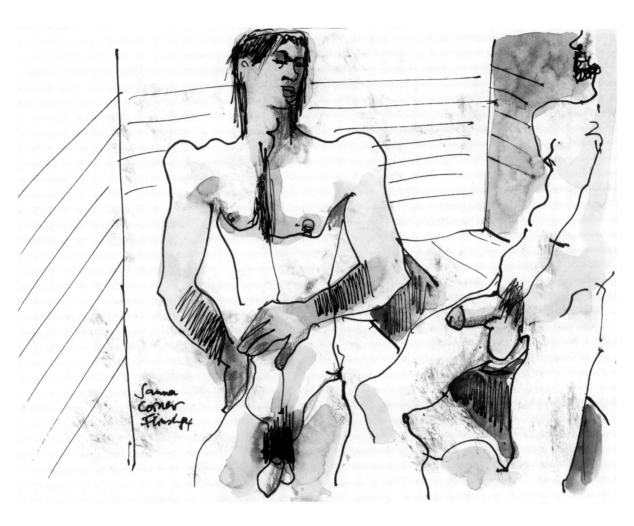

PLATE 44
Sauna Corner, 1984, pen and ink, washed with coffee, 23 x 30

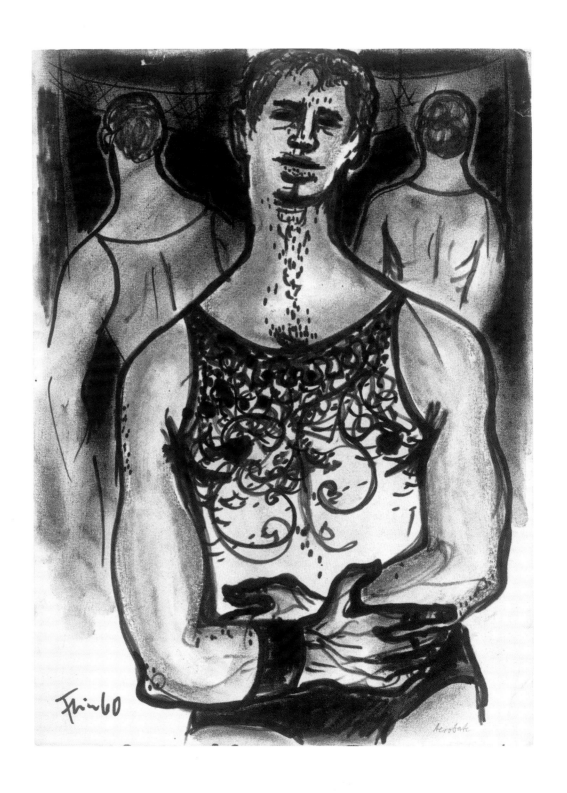

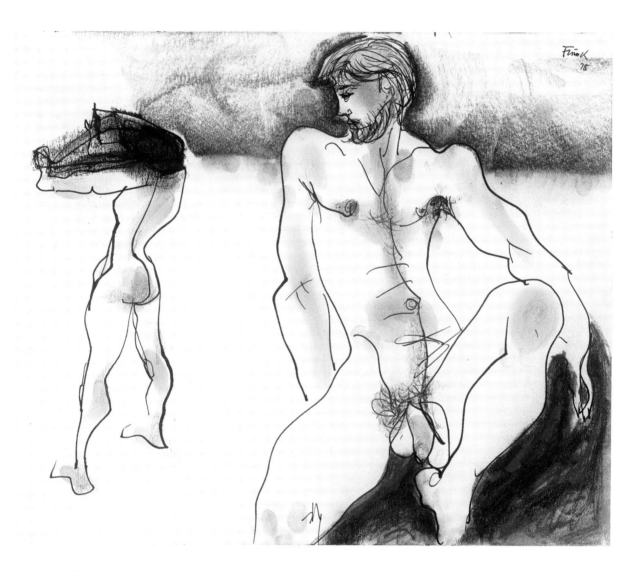

PLATE 45 (facing page)
Acrobat, 1960, felt pen and pastel, 38 x 28 cm

PLATE 46 (above)
Look Back in Joy, 1975, pen and ink and pastel, 36 x 43 cm

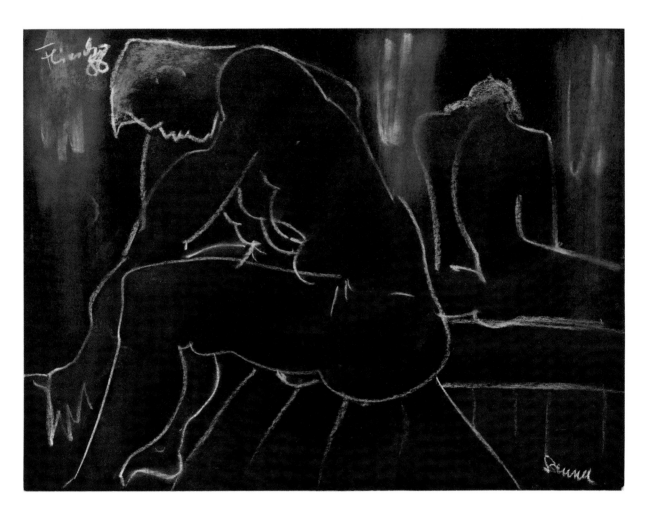

PLATE 47
Sauna, 1988, pastel on black board, 38 x 51 cm

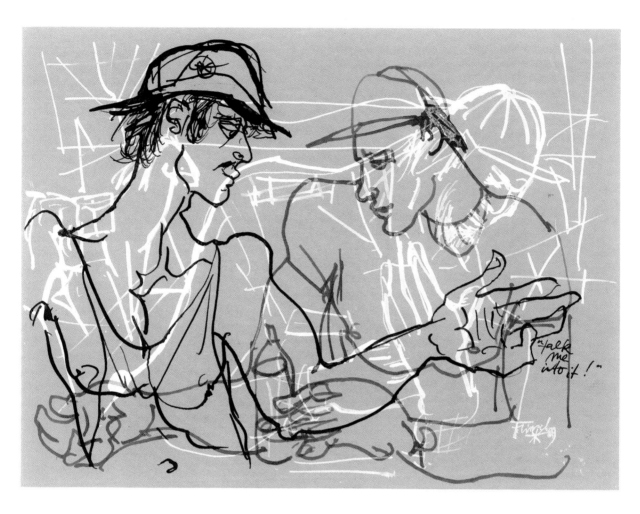

PLATE 48
Talk Me into It, 1989, pen and black, white, and red ink on gray paper. 23 x 30 cm

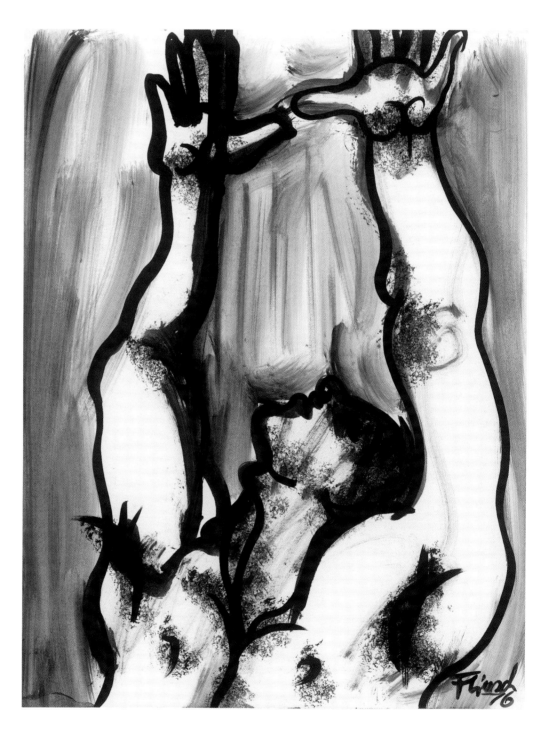

PLATE 49
Victory (study #1 for Olympic poster), 1976, brush and black ink, 61 x 46 cm

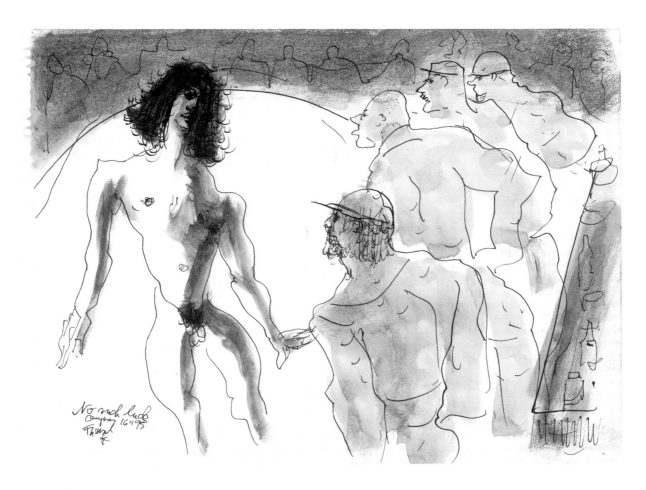

PLATE 50
No Such Luck (Campus), 1995, pen and ink, washed, 30 x 42 cm

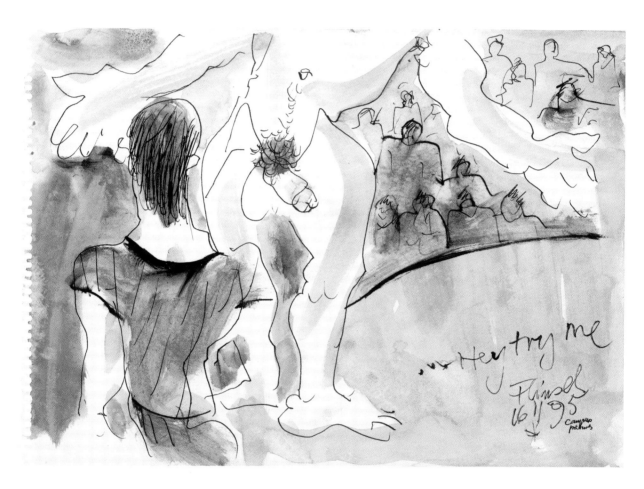

PLATE 51
Hey Try Me! (Campus), 1995, pen and ink, washed, 30 x 42 cm

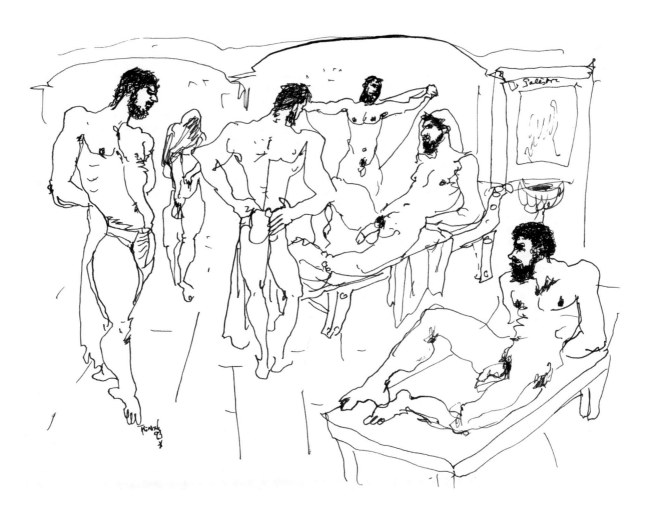

PLATE 52
Palestre, 1993, micropen, 35 x 27 cm

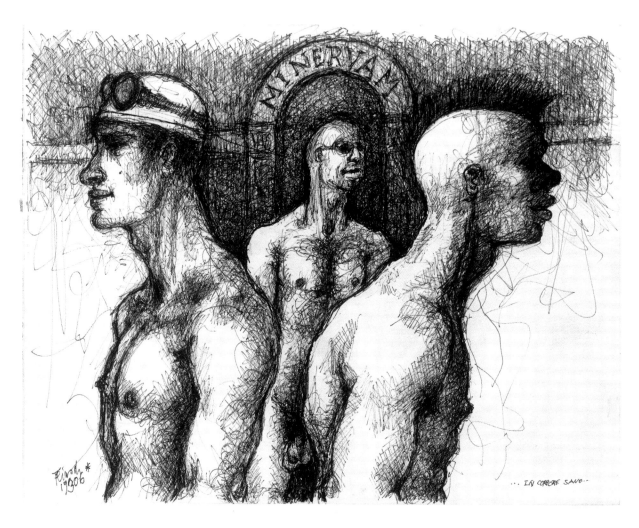

PLATE 53
In corpore sano, 2006, pen and ink, 28 x 36 cm

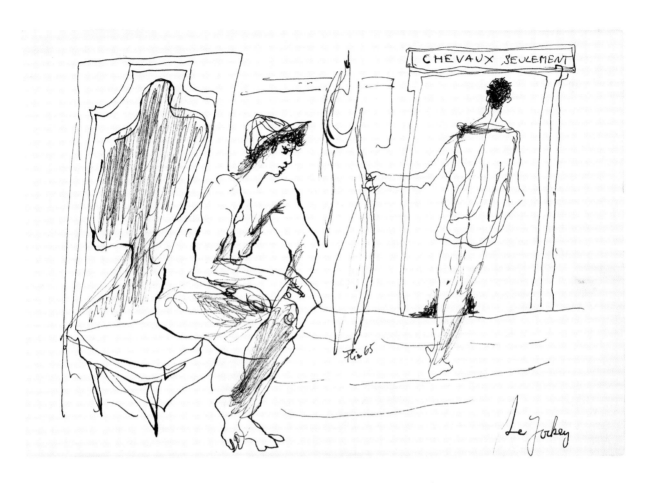

PLATE 54
Le jockey, 1965, pen and ink, 15 x 22 cm

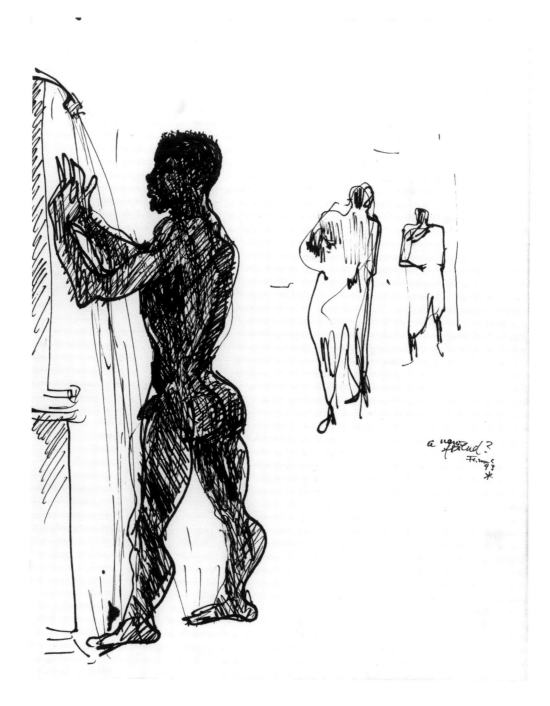

PLATE 55
A New Friend?, 1993, pen and ink, 35 x 27 cm

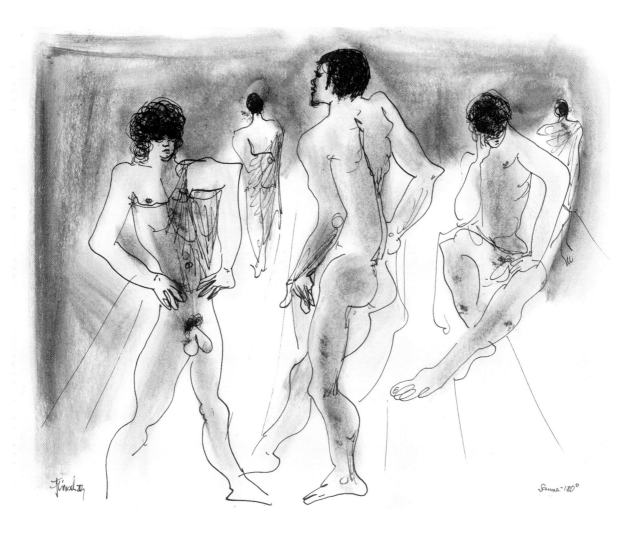

PLATE 56
Sauna 180 Degrees, 1979, pen and ink and watercolour, 28 x 35 cm

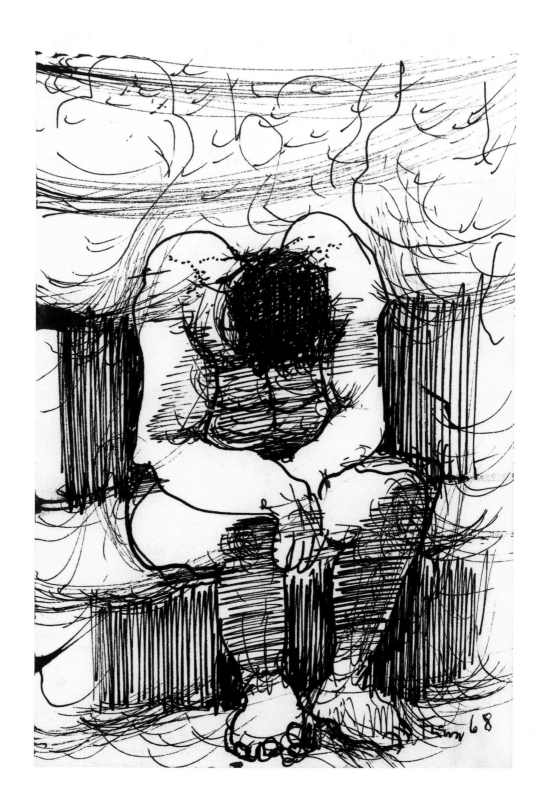

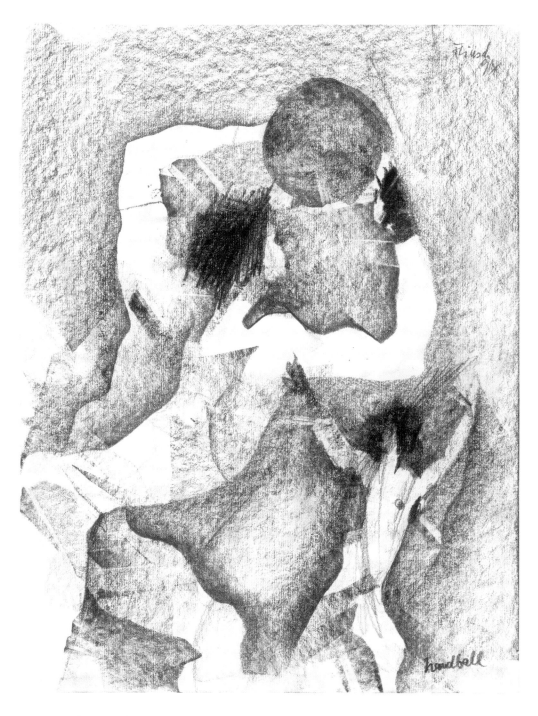

PLATE 57 (facing page)
In the Steam, 1968, pen and ink, 15 x 10 cm

PLATE 58 (above)
Hand Ball, 1998, graphite, 35 x 27 cm

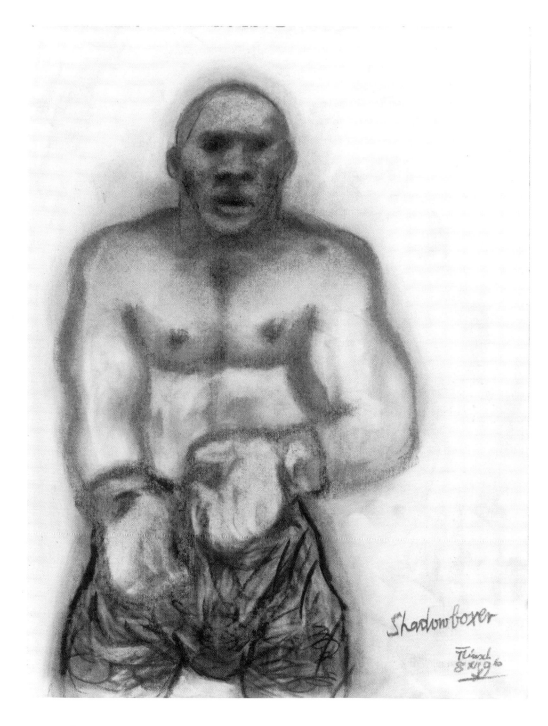

PLATE 59
Shadow Boxer, 1996, graphite, 35 x 27 cm

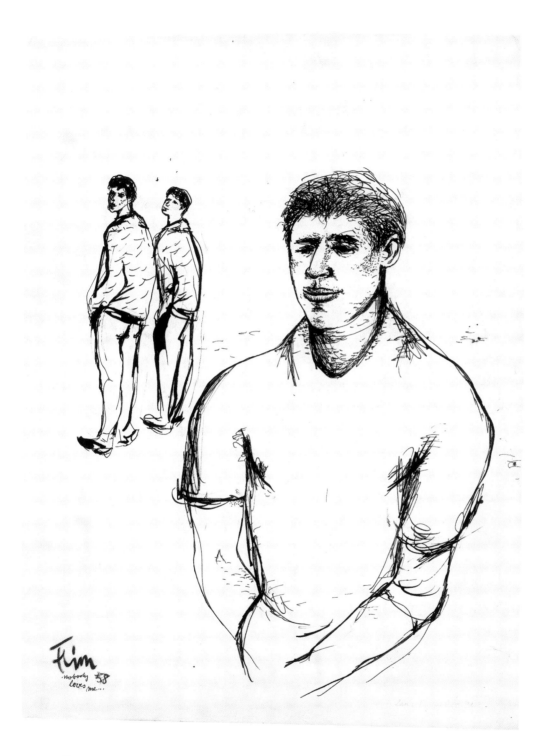

PLATE 60
Nobody Loves Me, 1958, pen and ink, 61 x 46 cm

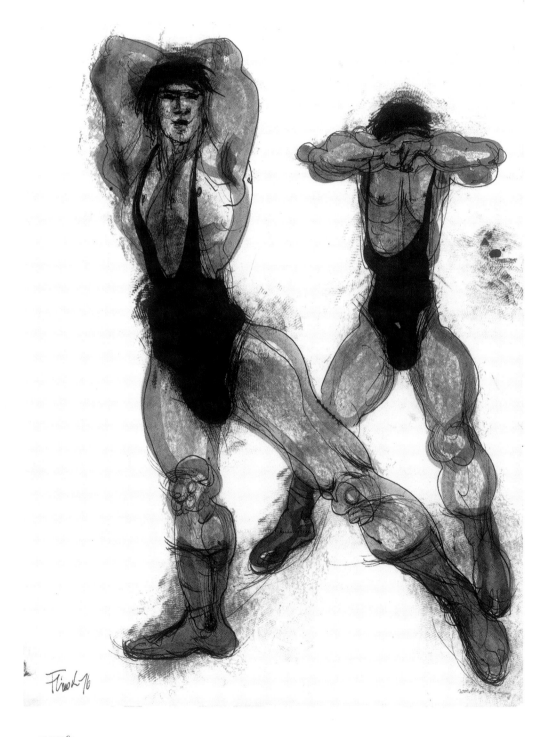

PLATE 61
Wrestlers Resting, 1976, pen and ink, washed, 61 x 46 cm

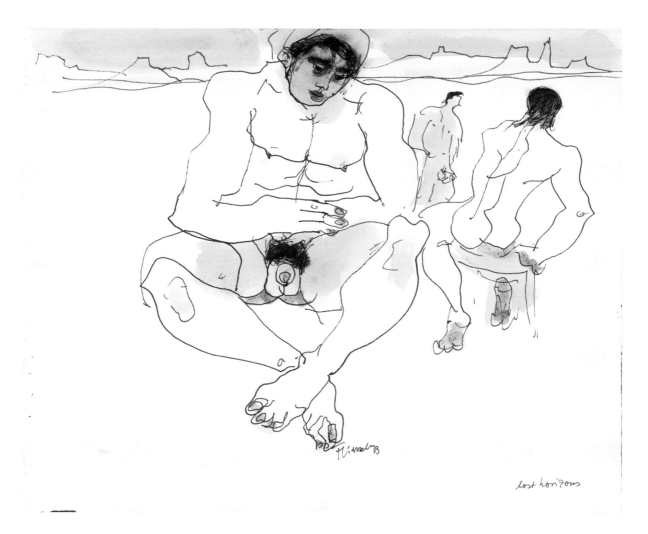

lost horizons

PLATE 62
Lost Horizons, 1973, pen and ink, washed, 28 x 35 cm

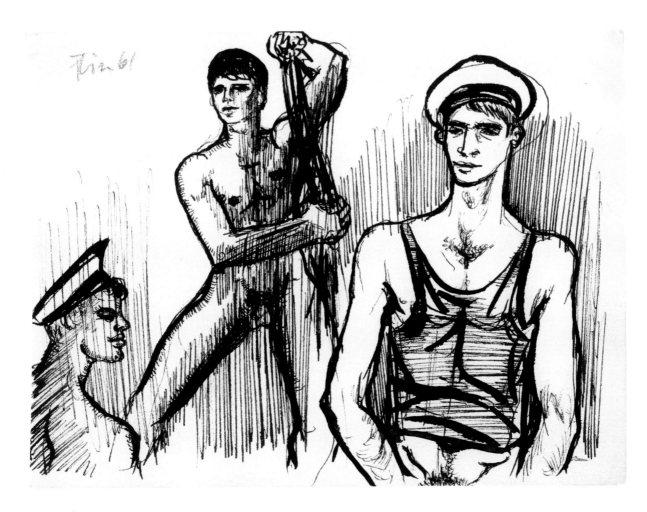

PLATE 63
Matelot, 1961, pen and ink, 12 x 17 cm

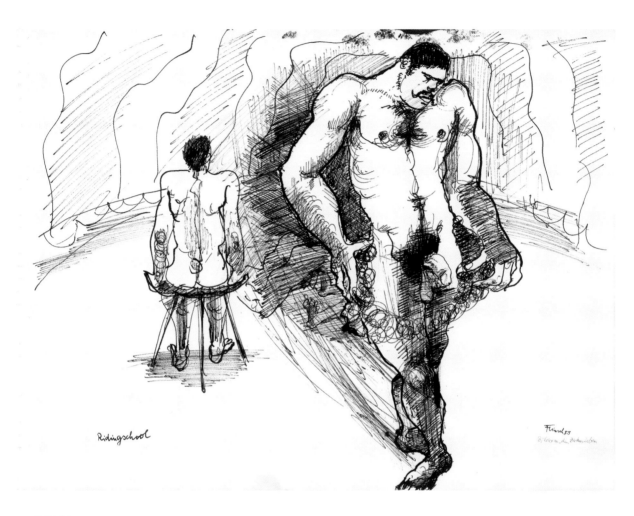

PLATE 64
Riding School, 1983, pen and ink, 23 x 30 cm

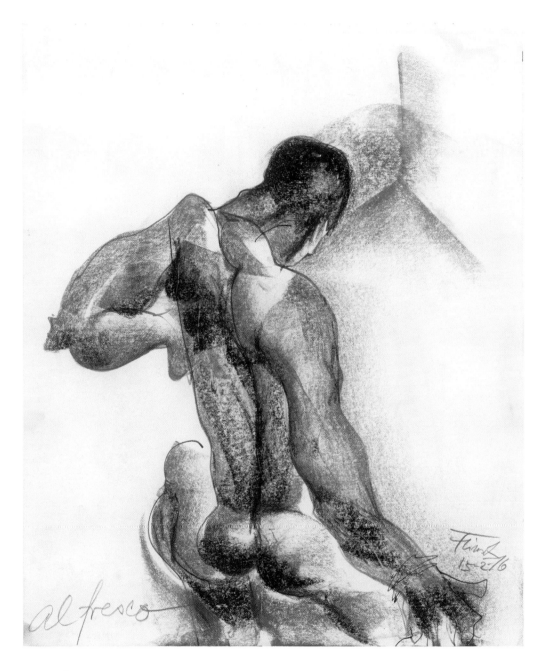

PLATE 65
Al fresco, 1976, pen and ink and pastel, 43 x 35 cm

PLATE 66 (facing page)
Les casques, 1973, pen and ink and colour spray, 17 x 13 cm

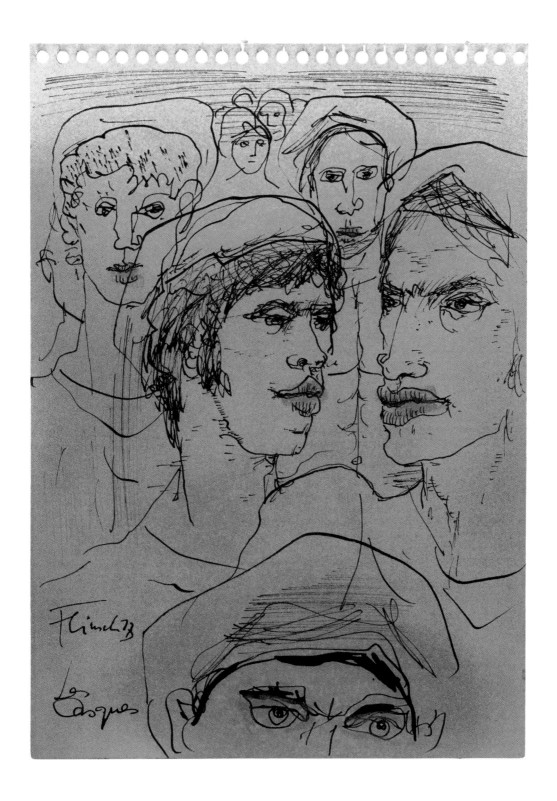

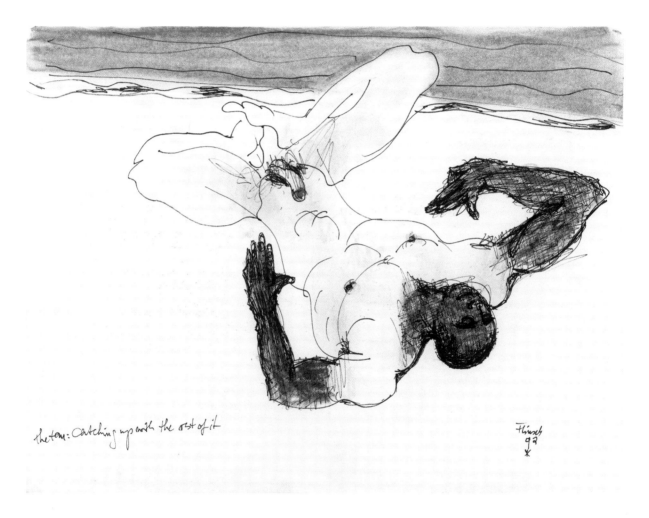

the tan: Catching up with the rest of it

Flinsch
93
x

PLATE 67
The Tan, 1992, pen and ink and watercolour, 27 x 35 cm

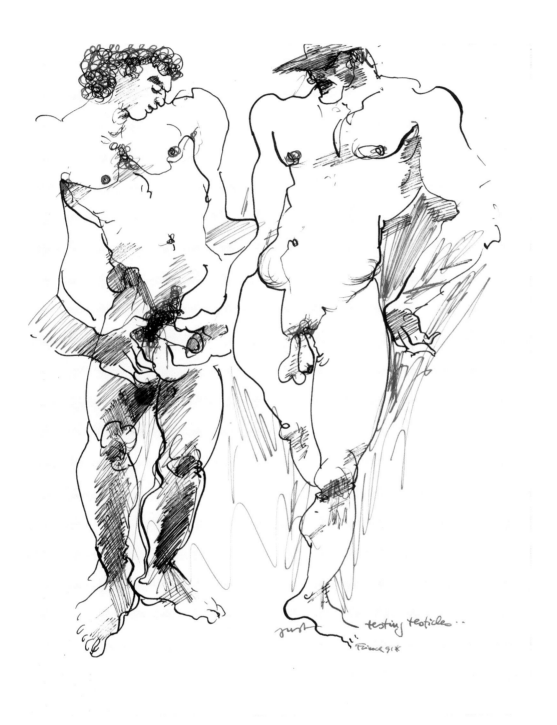

PLATE 68
Just Testing Testicles, 1991, pen and black and red ink, 35 x 27 cm

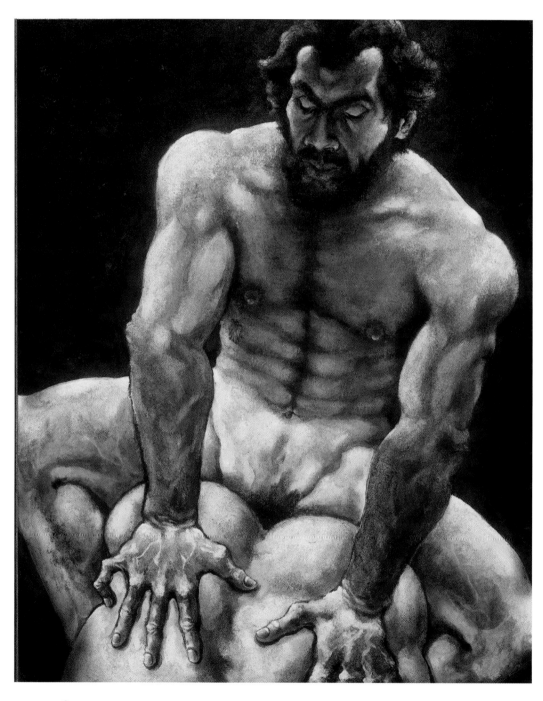

PLATE 69
Le cavalier, 1982, oil and graphite on board, 119 x 97 cm

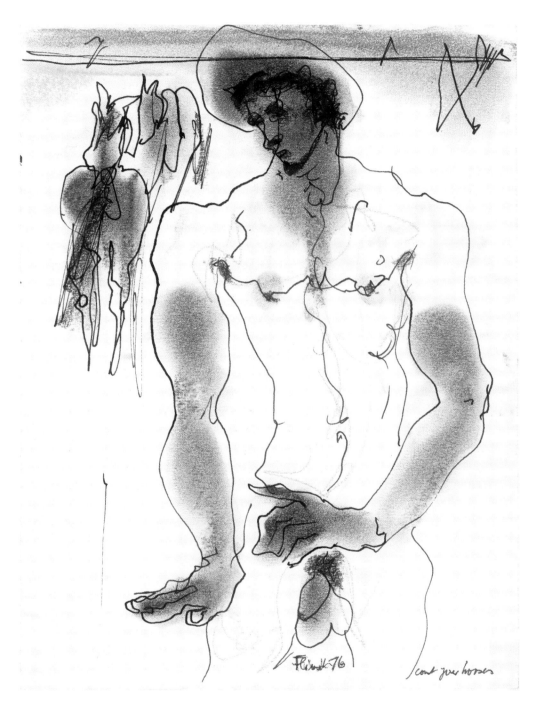

PLATE 70
Count Your Horses, 1976, pen and ink and pastel, 30 x 23 cm

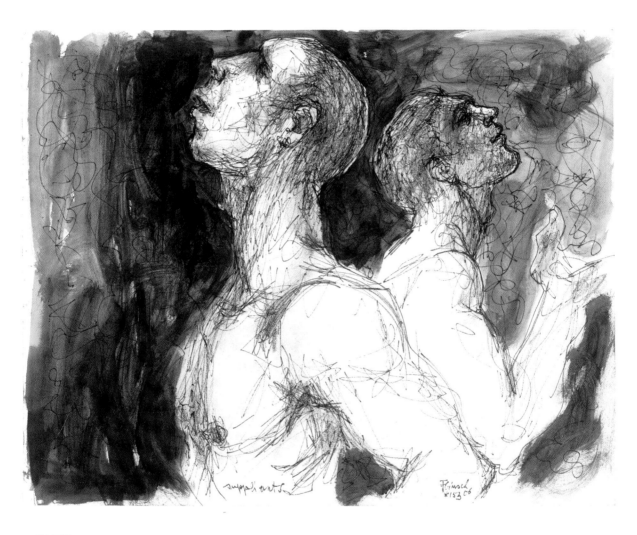

PLATE 71

Suppliant, 2006, micropen and watercolour, 27 x 35 cm

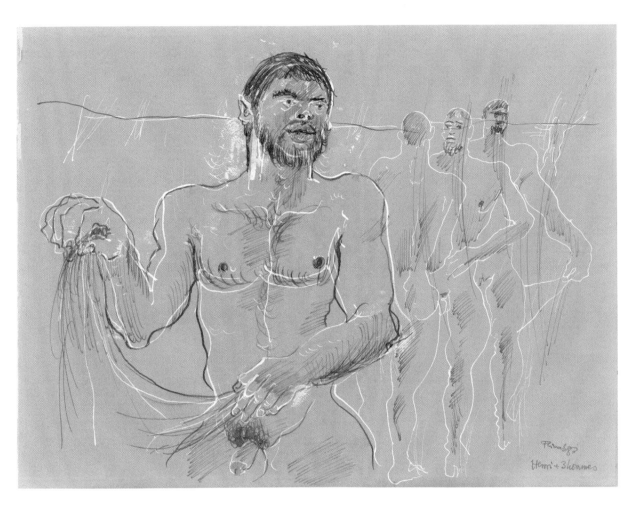

PLATE 72

Henri et 3 hommes, 1987, white and brown ink with pastel on grey paper, 23 x 27 cm

PLATE 73
In the Bicycle Shop, 1989, black marker and pastel on blue paper, 70 x 55 cm

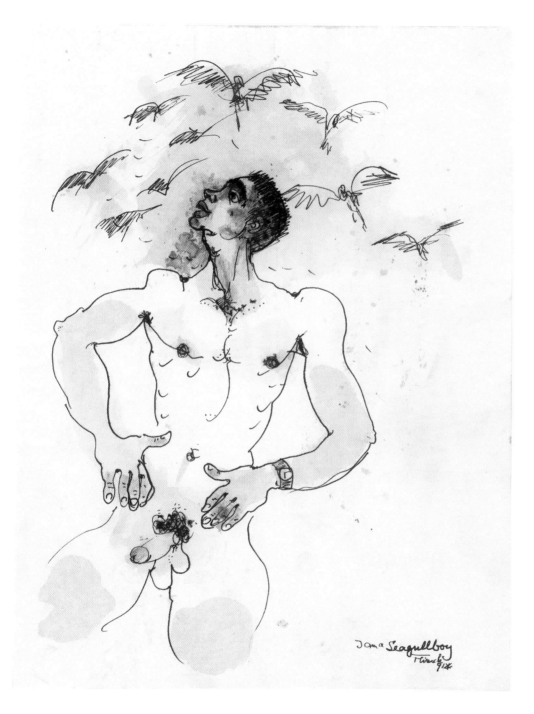

PLATE 74
I am a Seagull Boy, 1991, pen and ink and coffee wash, 35 x 27 cm

PLATE 75
Lemonade?, 1993, pen and ink and pastel, 35 x 27 cm

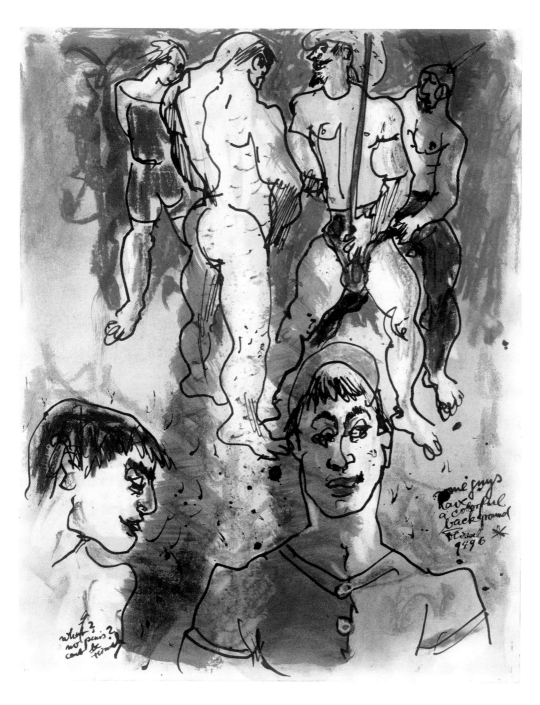

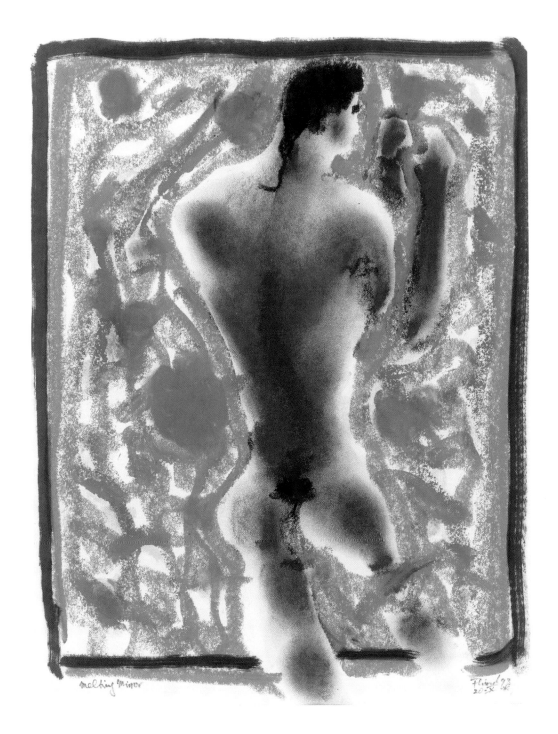

PLATE 77
Melting Mirror, 1993, pastel, 35 x 27 cm

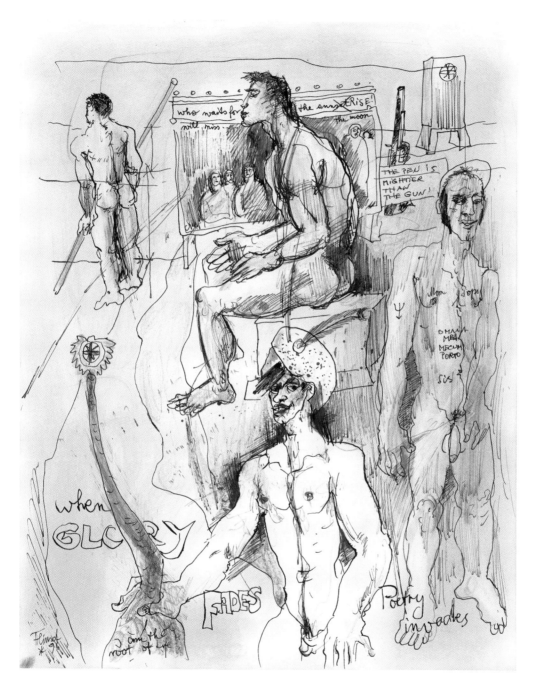

PLATE 78
I Am the Root of Life, 1996, pen and ink and watercolour, 35 x 27 cm

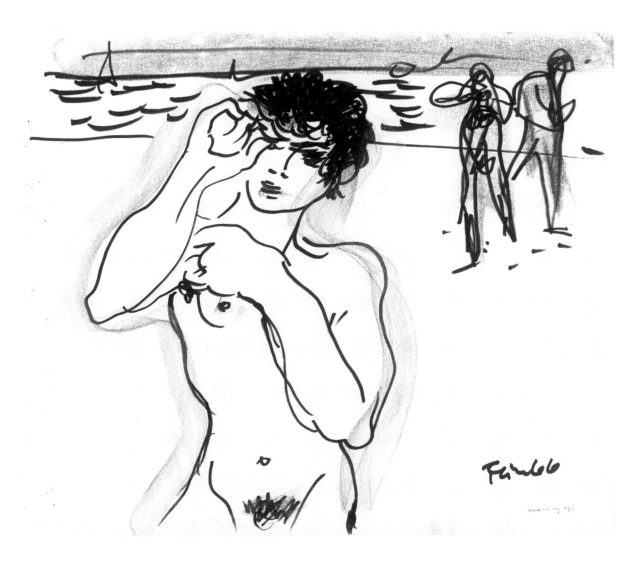

PLATE 79
Sand in My Eye, 1966, felt pen and pastel, 35 x 43 cm

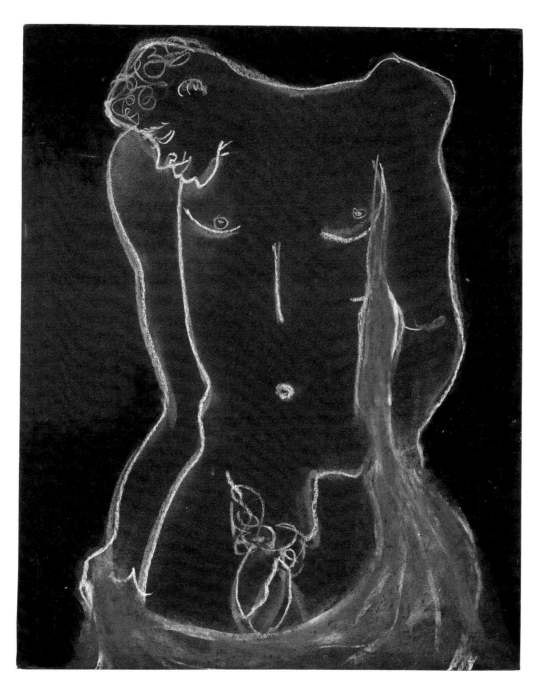

PLATE 80
Jeff & Red Drape, 2001, pastel on black board, varnished, 51 x 41 cm

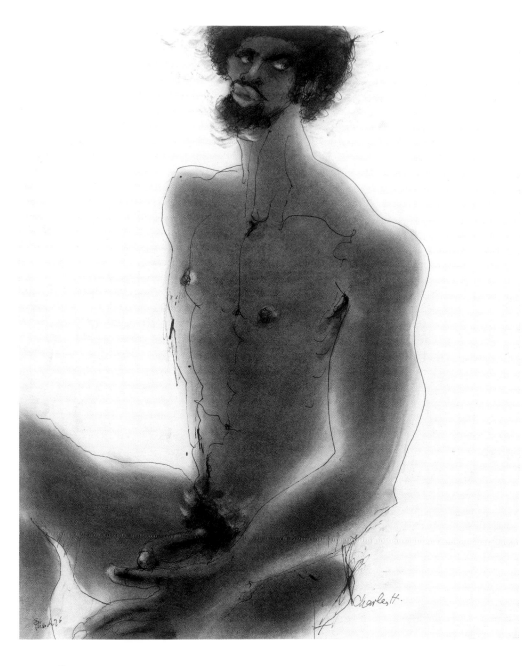

PLATE 81

Charles H., 1976, pen and ink and pastel, 43 x 35 cm

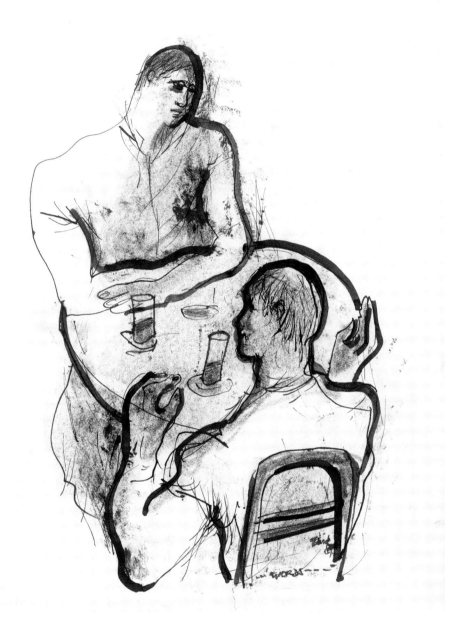

PLATE 82
Words, 1984, pen and ink and graphite, 43 x 36 cm

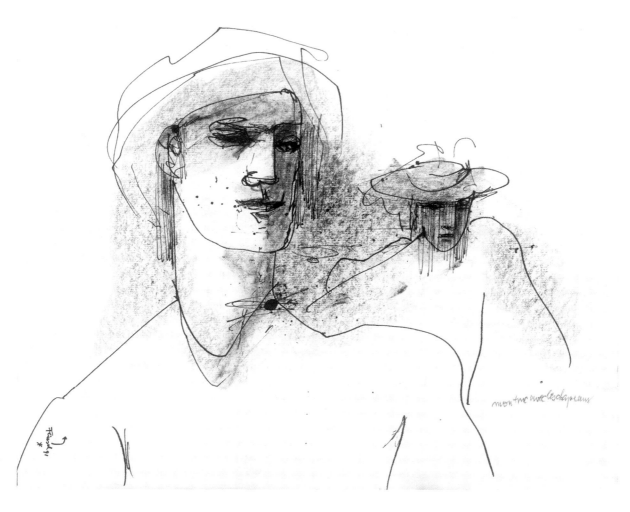

PLATE 83
Mon truc avec les chapeaux, 1991, pen and ink and graphite, 27 x 35 cm

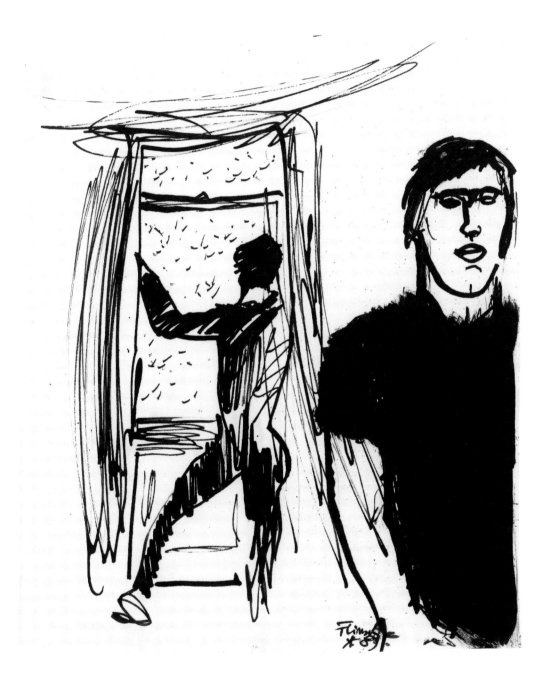

PLATE 84
Il pleut, 1989, pen and ink, 19 x 16 cm

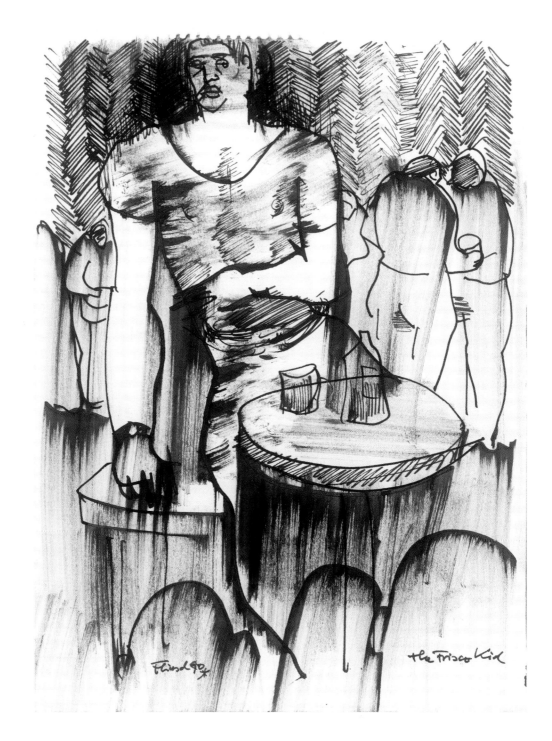

PLATE 85
The Frisco Kid, 1990, pen and ink, 32 x 24 cm

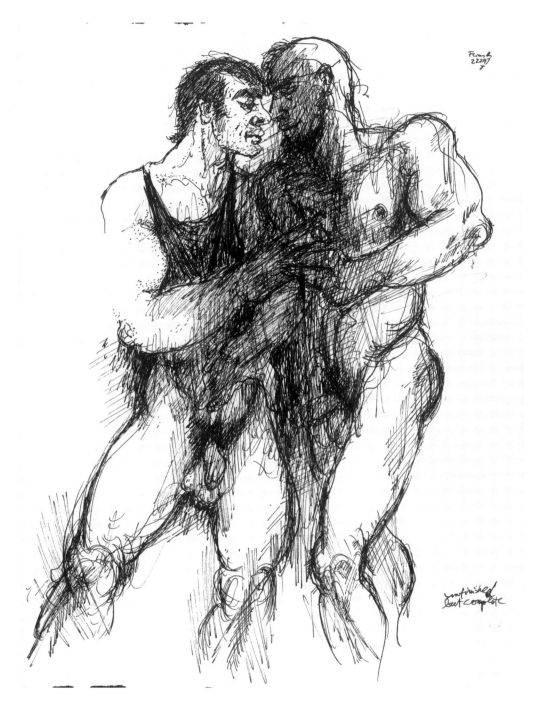

PLATE 86

Unfinished but Complete, 1997, micropen, 35 x 27 cm

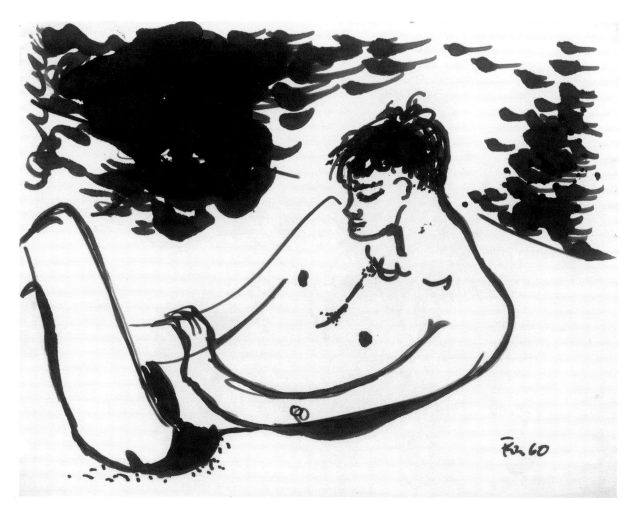

PLATE 87
A Boy, 1960, brush and black ink on tracing paper, 55 x 43 cm

PLAGE 88 (facing page)
Contemplation, 1986, micropen stippled, 22 x 13 cm

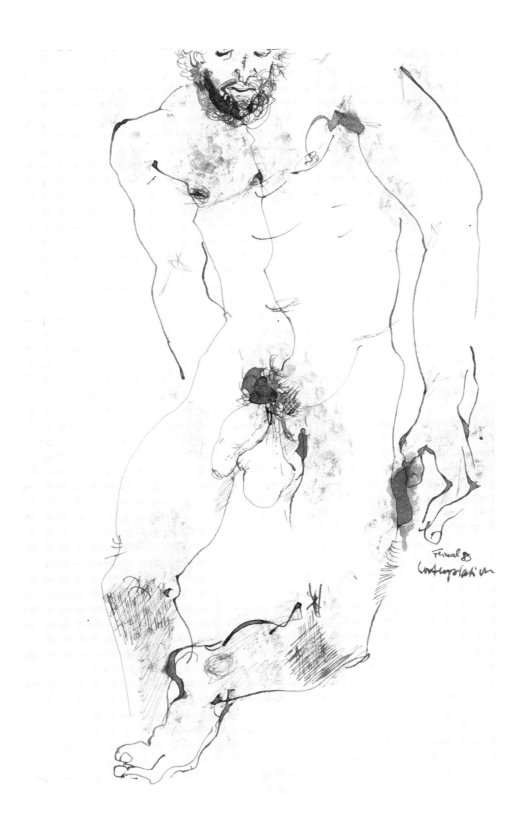

Freual 83
Contemplation

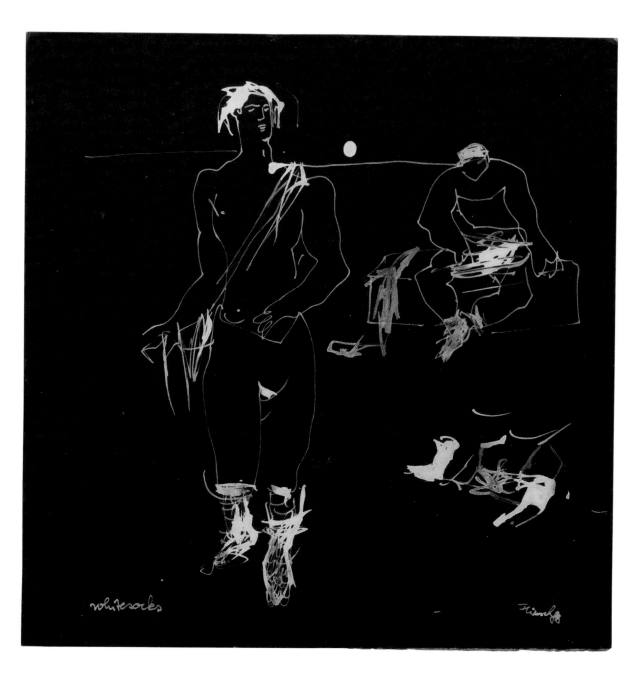

PLATE 89
White Socks, 1988, pen and white ink on black lacquered board, 39 x 38 cm

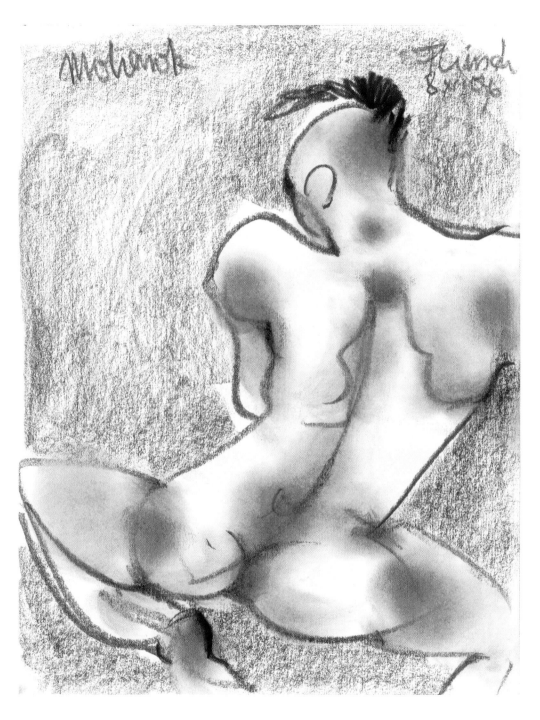

PLATE 90
Mohawk, 1996, graphite, 35 x 27 cm

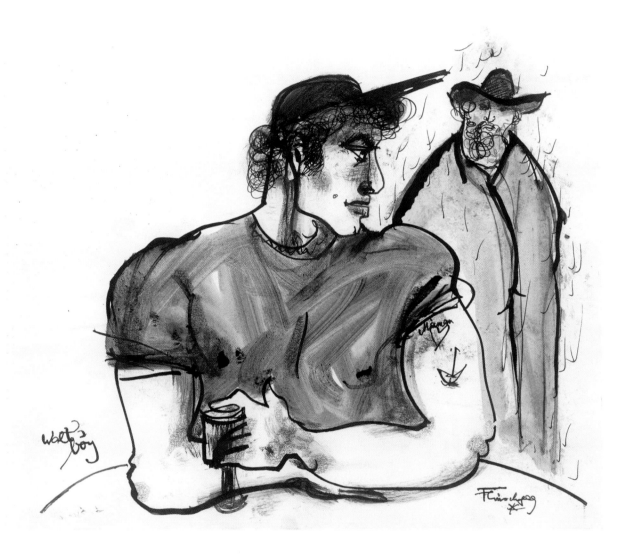

PLATE 91
Walt's Boy, 1989, pen and ink, washed. 35 x 43 cm

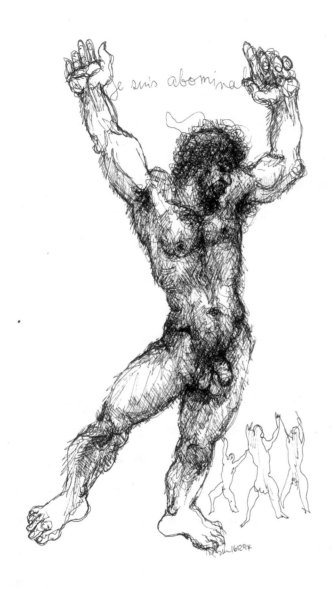

the origine of the species... d'après nature...

PLATE 92
The Origin of the Species, 2001, pen and ink, 35 x 26 cm

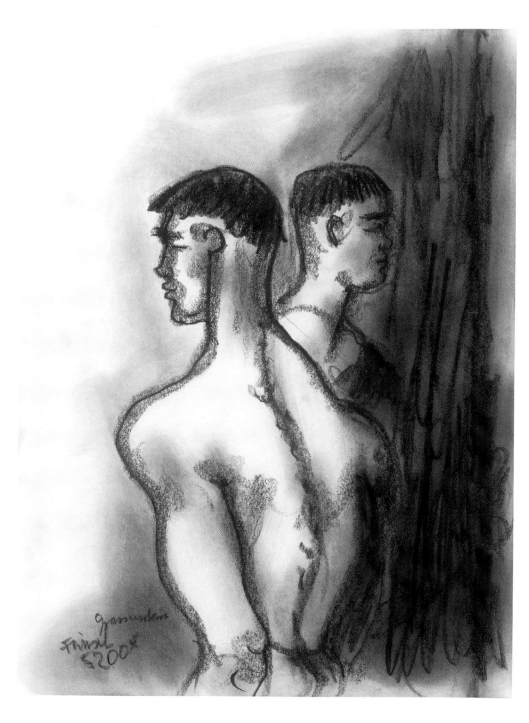

PLATE 93
Grass Curtain, 2000, graphite wiped, 35 x 27 cm

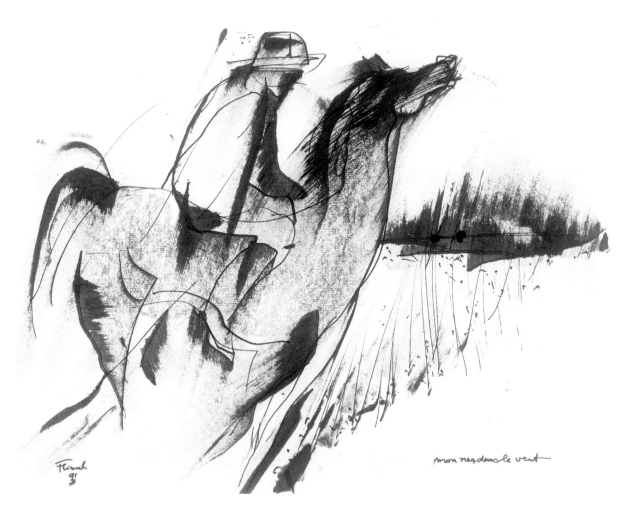

PLATE 94

Mon nez dans le vent, 1991, pen and ink and graphite, 27 x 35 cm

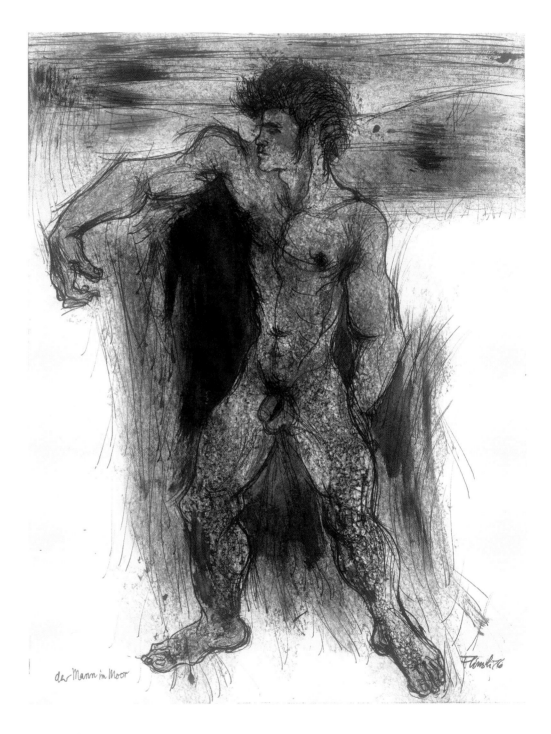

der Mann im Moor

PLATE 95
Der Mann im Moor, 1976, pen and ink sponged, 61 x 46 cm

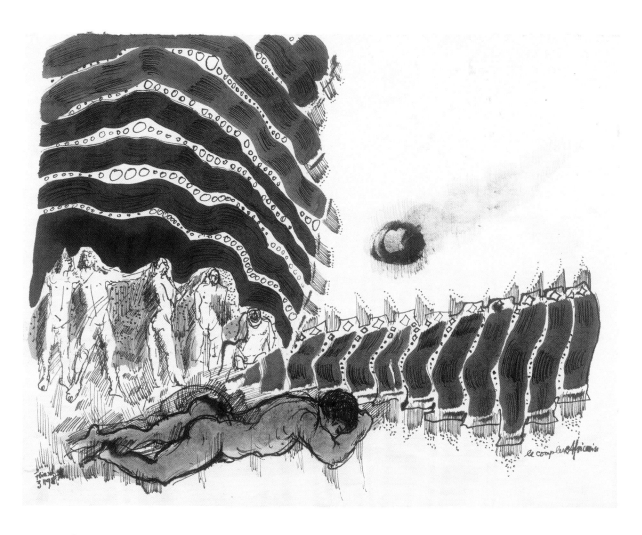

PLATE 96
Le complexe africain, 1998, pen and ink, washed, 27 x 35 cm

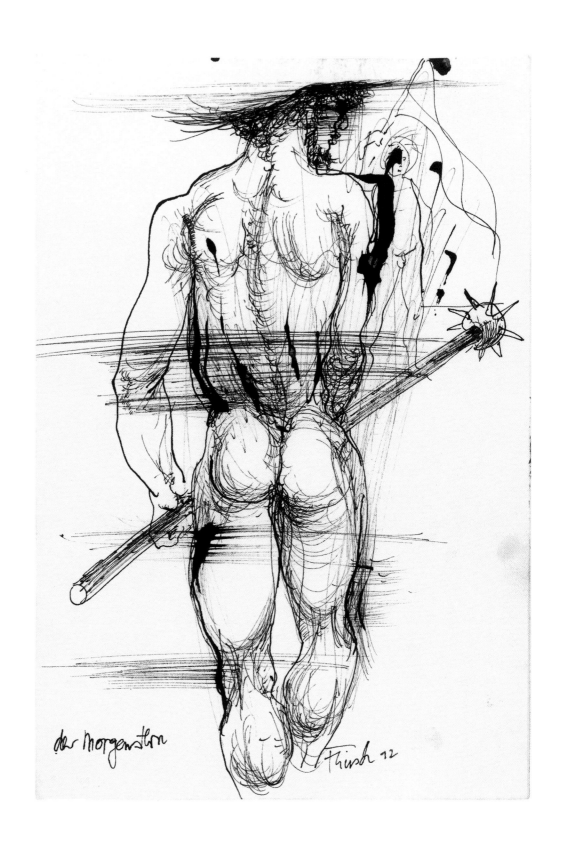

der morgenstern

Hirsch 72

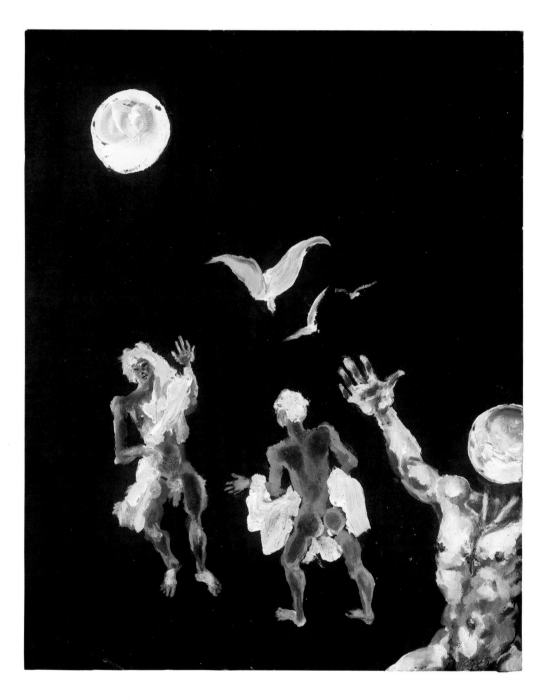

PLATE 97 (facing page)
Der Morgenstern, 1972, pen and ink, 22 x 15 cm

PLATE 98 (above)
Moonstruck / Lunaire, 2005, oil on black board, 51 x 40 cm

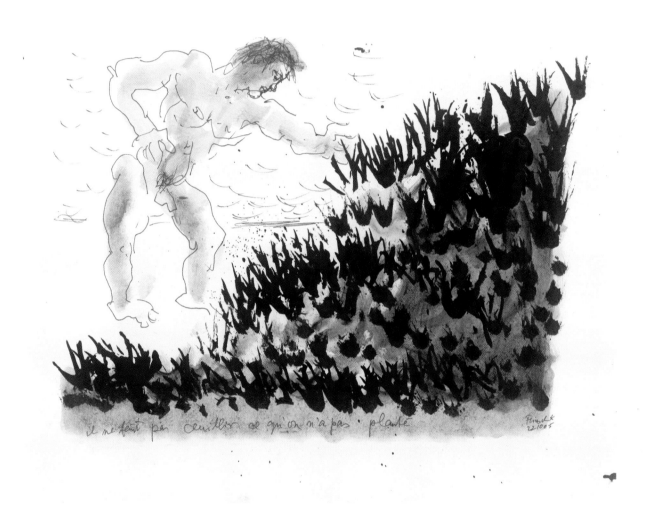

PLATE 99

Il ne faut pas cueillir ce qu'on n'a pas planté, 2005, micropen and brush and ink, 27 x 36 cm

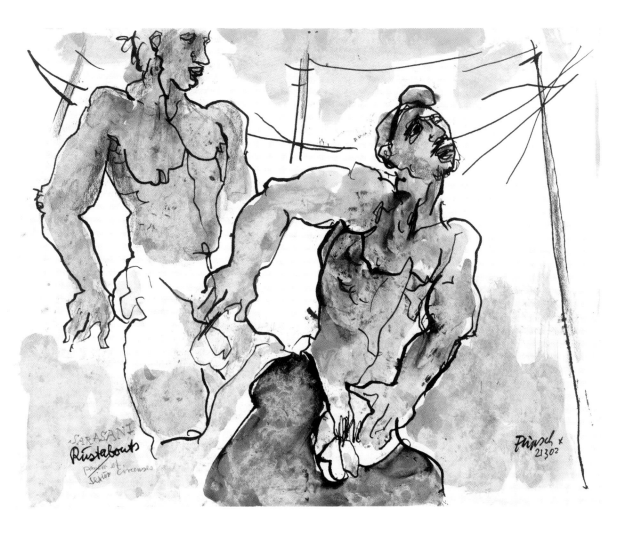

PLATE 100

Roustabouts, 2002, pen and ink and watercolour, 28 x 36 cm

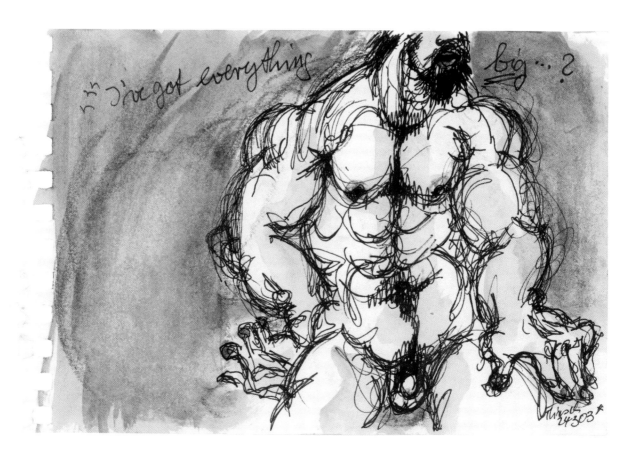

PLATE 101
I've Got Everything Big?, 2003, micropen and watercolour, 10 x 14 cm

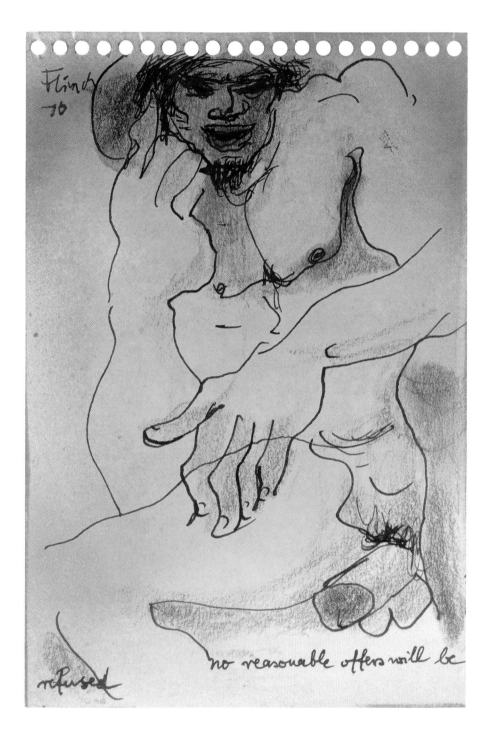

PLATE 102
No Reasonable Offers Will Be Refused, 1970, pen and ink and pastel, 14 x 10 cm

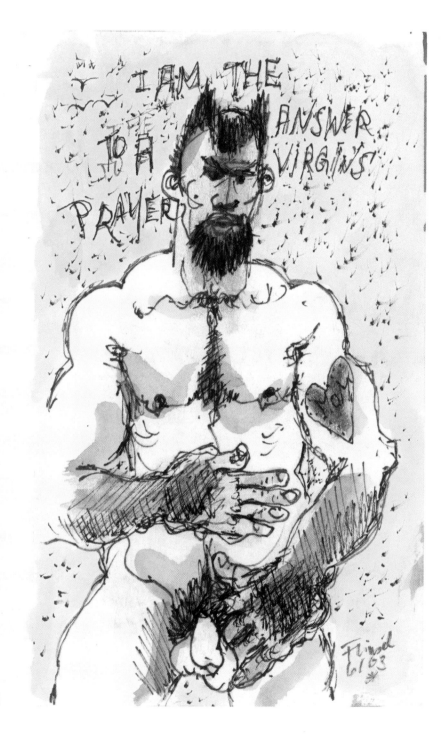

PLATE 103
I Am the Answer to a Virgin's Prayer, 2003, micropen and watercolour, 14 x 10 cm

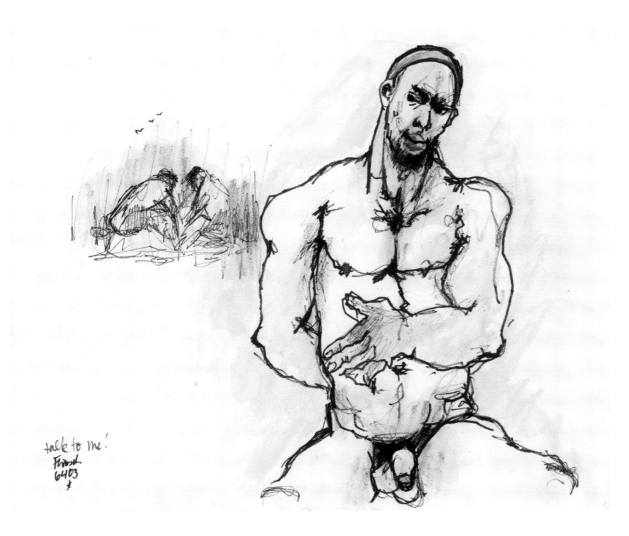

PLATE 104
Talk to Me, 2003, pen and ink and pastel, 35 x 28 cm

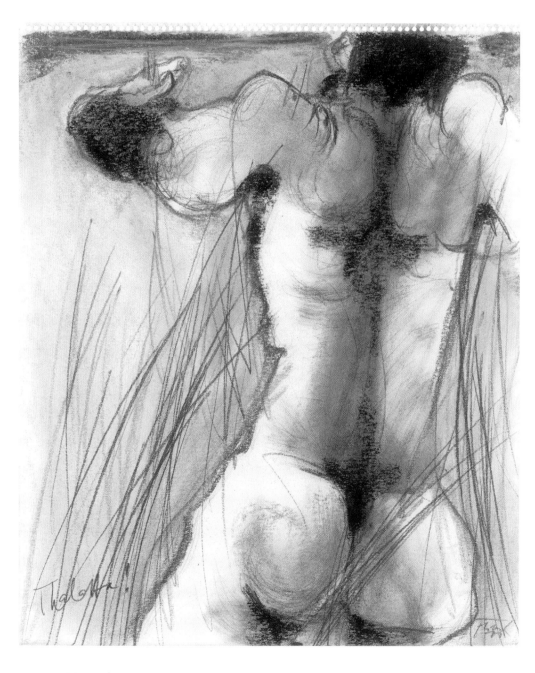

PLATE 105
Thalatta!, 1977, graphite and pastel, 43 x 25 cm

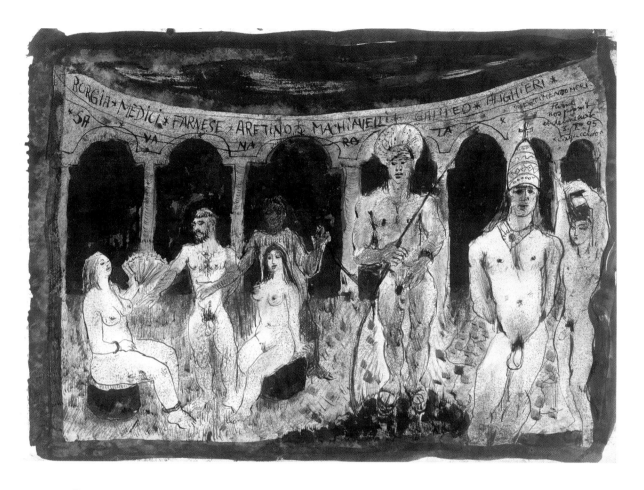

PLATE 106
Playing Pope, 1995, pen and ink and watercolour, 30 x 42 cm

PLATE 107
Life Is a Ball Game, 1996, pen and ink and pastel, 35 x 27 cm

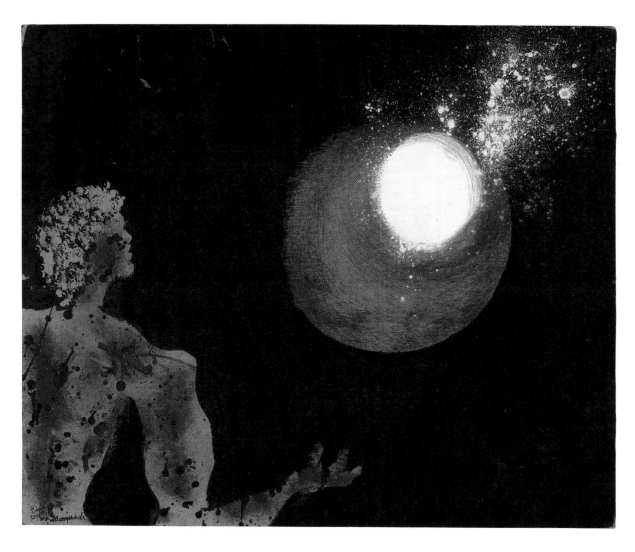

PLATE 108
Moon Speckles, 2004, oil and pen and ink on black board, 36 x 43 cm

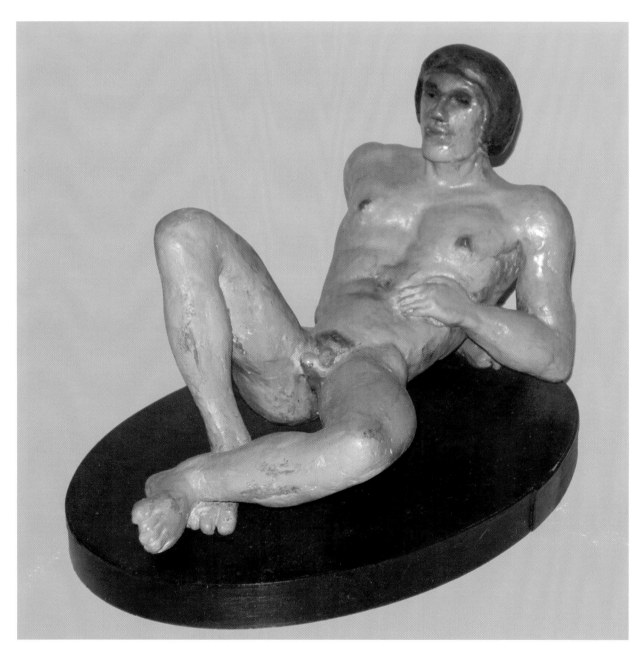

PLATE 109
Ray Reclining, 1998, polyfilla and oil paint, 10 x 8 cm x 18

PLATE 110 (facing page)
David Rising with Head of Goliath, 1991, polyfilla and gilt paint, 36 x 28 x 28cm

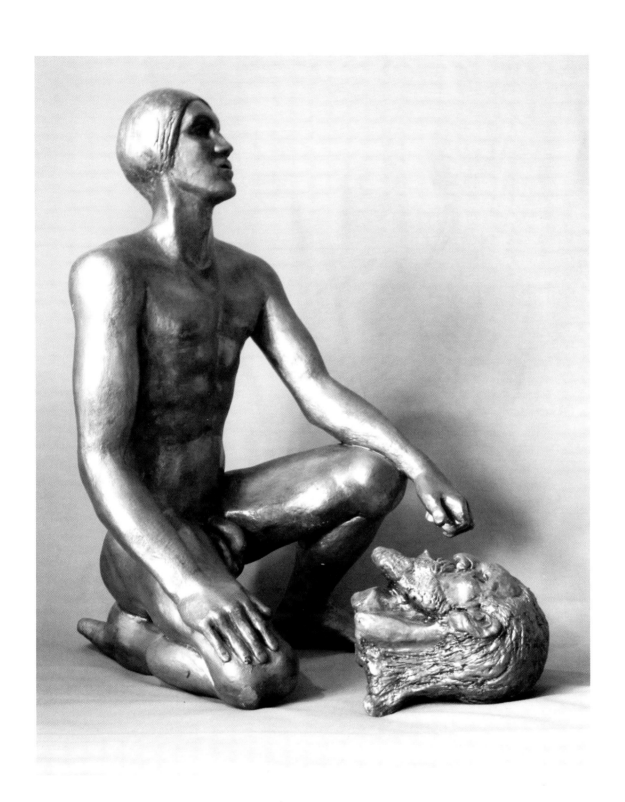

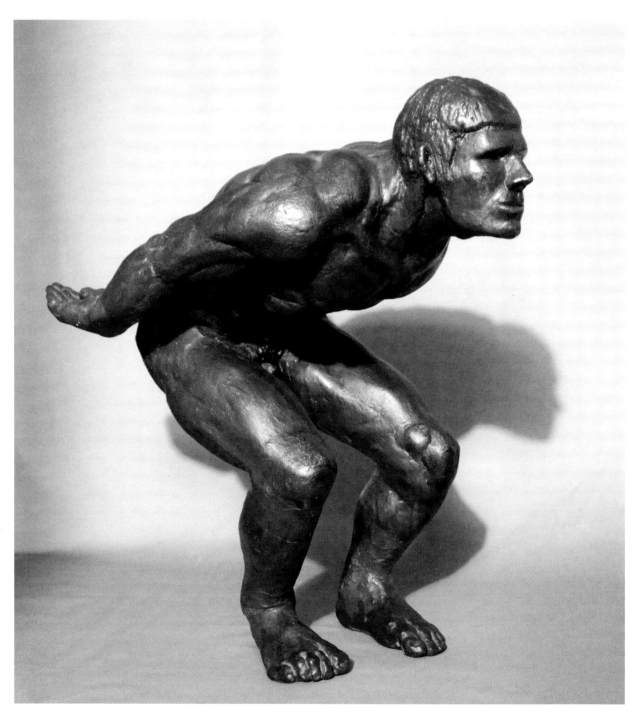

PLATE III
The Swimmer, 1986, polyfilla and bronze paint, 52 x 47 x 33 cm

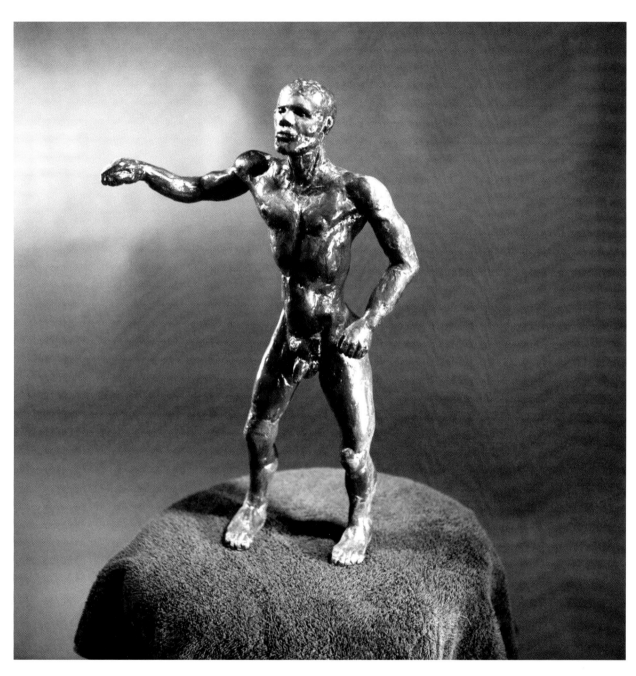

PLATE II2
The Black Man, 1989, polyfilla and oil paint, 43 x 30 x 9 cm

PLATES

INDEX

ALSO AVAILABLE FROM **ARSENAL PULP PRESS**:

Comin' at Ya!: The Homoerotic 3-D Photrographs of Denny Denfield
by David L. Chapman and Thomas Waugh

The Dictionary of Homophobia
edited by Louis-Georges Tin

Gay Art: A Historic Collection
by Felix Lance Falkon with Thomas Waugh

Lust Unearthed: Vintage Gay Graphics from the DuBek Collection
by Thomas Waugh with Willie Walker

Out/Lines: Underground Gay Graphics from Before Stonewall
by Thomas Waugh

The View from Here: Conversations with Gay & Lesbian Filmmakers
by Matthew Hays

For more information on these and other titles, visit *arsenalpulp.com*.

Marquis Book Printing Inc.

Québec, Canada
2008